SANTA FE BOHEMIA
THE ART COLONY
1964–1980

SANTA FE BOHEMIA
THE ART COLONY
1964-1980

ELI LEVIN

SUNSTONE
PRESS

SANTA FE

Book design by Vicki Ahl

Sunstone books may be purchased for educational, business, or sales promotional use. For information please write: Special Markets Department, Sunstone Press, P.O. Box 2321, Santa Fe, New Mexico 87504-2321.

Library of Congress Cataloging-in-Publication Data

Levin, Eli, 1938-
 Santa Fe bohemia : the art colony, 1964-1980 / Eli Levin.
 p. cm.
 ISBN 0-86534-512-0 (hardcover : alk. paper) -- ISBN 0-86534-513-9 (softcover : alk. paper)
 1. Art, American--New Mexico--Santa Fe--20th century. 2. Artist colonies--New Mexico--Santa Fe--History--20th century. I. Title.

N6535.S33L48 2007
709.789'5604--dc22

 2006037307

Published in

WWW.SUNSTONEPRESS.COM
SUNSTONE PRESS / POST OFFICE BOX 2321 / SANTA FE, NM 87504-2321 /USA
(505) 988-4418 / ORDERS ONLY (800) 243-5644 / FAX (505) 988-1025

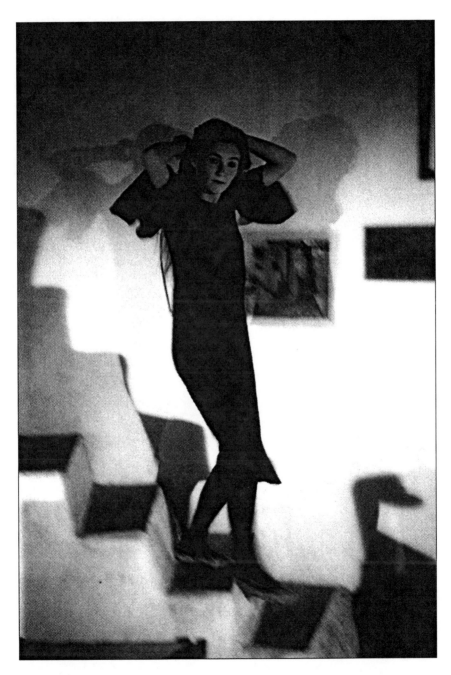

Sarah McCarty, c. 1982. Photo by Bernard Plossu. Courtesy of Eaton Fine Art.
Dedicated to Sarah McCarty; remembering the good old days.

CONTENTS

ACKNOWLEDGEMENTS

I would like to extend warm regards to the many friends who shared those magic years despite any little jibes I might have voiced. Particularly, Maria Martinez lent her peculiar enchantment to the early days.

Charlotte Golin generously first typed and edited the manuscript. Robert Mayer, a novelist I admire, did comprehensive editing and a search for libel. Jim and Carl of Sunstone Press shared their arcane knowledge of issues of propriety, as well as other publishing wisdom. Eric Thomson, my partner at Argos Gallery, gave the text an exacting final reading thanks to which many artists will have their names spelled correctly. Finally, Cheryl Anne Lorance, my other gallery partner, defied many maddening impediments in her comprehensive and successful effort to ferret out fascinating visual material.

FOREWORD

At the time I wrote this book, 1987, I had lived in Santa Fe for twenty-three years. What follows is a remembrance of the artists I met here between 1964 and 1980.

I grew up in New York, in Manhattan, and studied art there. Then I spent five years of student life and early career in Boston. I came out West for a new start at the age of twenty-six.

As I approached Taos, I saw a roadside tourist sign that mentioned D.H. Lawrence and the Taos art colony. This intrigued me, and I stayed a month. Having found Taos hard to adjust to, I continued to Santa Fe.

Here too, traces of an old art colony were abundant. Everyone talked about the good old days. There was a generation gap: the artists I met were old, often doddering. Several of these old-timers died in my first few years here, among them Gustave Baumann, Will Shuster, Randall Davey and Josef Bakos. A little later, Eugenie Shonnard, Howard Cook and Andrew Dasburg also died.

Santa Fe was very welcoming. The local people were familiar with art, sympathetic to artists. The old generation enjoyed my questions and there were few artists my age to compete with.

By the early 1970s, other young artists started discovering Santa Fe. Like the hippies, they were on the run from city life. An active bohemian colony developed. We had something special. Santa Fe was so beautiful, and we were so sincere.

Santa Fe was a cultural boom town. The number of galleries went from two to a hundred. Besides the Santa Fe Opera, which had only existed for about ten years when I arrived, there came into being endless festivals for art, music, literature, theater, movies, fashion, and the crafts of Indians and Spanish Americans. Aesthetic considerations have often become tourist clichés. The city's complex heritage of three interlocked cultures became "Santa Fe Style."

By the 1980s the Renaissance was over. Highbrows and committed artists were returning to the urban centers or trying to find cheaper places to live. Artists who stayed on withdrew from the public eye or faltered in their purpose. Some who had built their own studios went into construction and land development. Hippies opened boutiques.

The happy sense of finding a creative center that made me stay in Santa Fe has blurred, but I am comfortable. My earlier memories, though frayed at the edges, seem more poignant than recent ones. Perhaps when I look back at the past few years, a continuity will become apparent. Or maybe those first fifteen years did have a special magic. I stop the narrative around 1980. Recent friends can feel relieved.

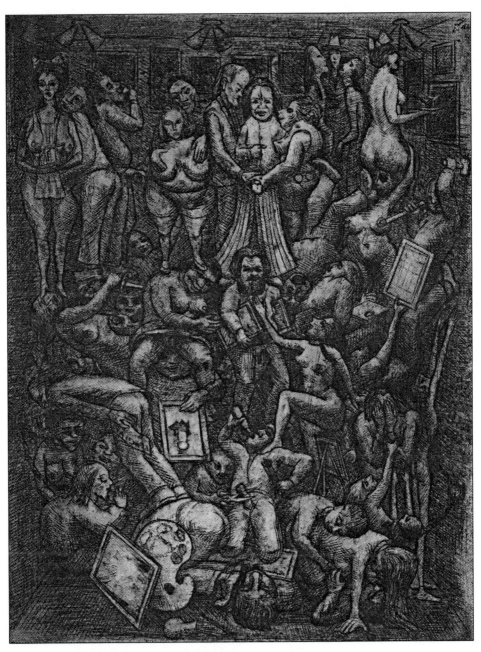

The Santa Fe Art Scene, Eli Levin, engraving, 10 in. x 8 in.

ARRIVING IN SANTA FE

I arrived in Santa Fe in June of 1964 on a small motorbike, having spent two months wending my way westward. I had just turned twenty-six. First I found the Plaza. Someone told me that Canyon Road was where the artists lived so I went there. Canyon was a dirt road, and there were several artists' studios open to the public, interspersed with private homes.

Canyon Road had long been Santa Fe's bohemian neighborhood. It developed in the 1920s and 1930s when Los Cinco Pintores (the Five Painters, the name given to the five artists Will Shuster, Josef Bakos, Fremont Ellis, Walter Mruk, and Willard Nash) built studios on the adjacent Camino del Monte Sol. At the same time other artists built on the Road: Randall Davey in the mill at the top, Gerald Cassidy in the apple orchards, and Theodore Von Soelen, farther down by the enormous chestnut tree.

The Road has grown with the rest of the city, and is now a high rent district, but nevertheless has more artists and craftspeople than ever. Furthermore, the art scene has spilled over into other parts of town. Business-oriented dealers have moved as close to the Plaza as

possible, to catch the dense tourist traffic. Artists and craftspeople, unable to find or afford Canyon Road space, have moved down by the tracks, to the Montezuma-Guadalupe neighborhood with its Soho-like warehouses.

When I came to town, my first contacts were on Canyon Road, and it has been central for me ever since. The Road was a hidden enclave approached by way of The Oldest Church and then up De Vargas. Santa Fe's only art store, The Paint Pot, was behind the church. From there, I walked up a winding narrow alley, flanked by ancient houses. This area has since been ruined by the PERA Building.

De Vargas joins Canyon at the corner of Garcia, where the artist John Sloan lived. Chuzo Tamotzu, an artist, was using his studio when I arrived. A little farther one saw a number of unprepossessing studios, simple adobes with "OPEN" signs propped on windows or doorsills. The artists were not hard to find and they were often ready for a long conversation. That first day I met Jim Morris, Tommy Macaione and Hal West.

Hal West stood in his doorway, the screen door hanging awry. He invited me in for coffee. Despite the darkness and disorder lurking behind him, I accepted, intrigued by the painting of a hitchhiker in the window. Once inside, I was pleased to find some Depression style paintings amid all the clutter.

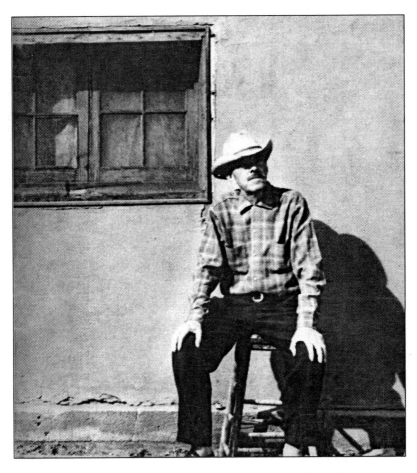

Hal West sunning beside his Canyon Road studio.
Photo by Roy Rosen.

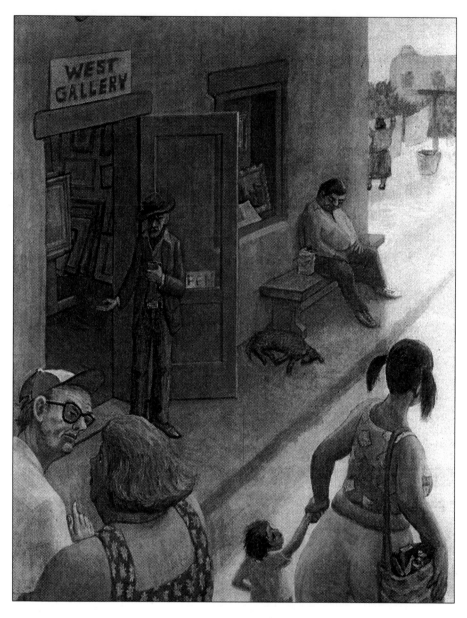

Hal West's Gallery, Eli Levin, 1991, Egg tempera, 20 in. x 16 in.
Collection of Marilyn Maxwell.

Hawk and Hitchhiker, Hal West, 1949, Oil on canvas.
Collection of the Museum of Fine Arts, New Mexico.
Gift of Ms. Lynda Duniven in memory of Mrs. Floriene Duniven, 1979.
This is the painting I saw in Hal's window
when I first went up Canyon Road.

Later, as I rode my motorbike slowly up the street, it started to rain. Junius Stowe, a furniture restorer, was standing by the well in front of his little shop. He invited me to take cover. Some years later this shop became my studio, Laughing Boy Gallery. Junius was embarrassingly friendly, a puffy old alcoholic. We walked behind his studio to his house. A friend of his was there. They gave me a whiskey and told me how cultural Santa Fe was, and especially they went on about the Santa Fe Opera, founded in 1956 by John Crosby.

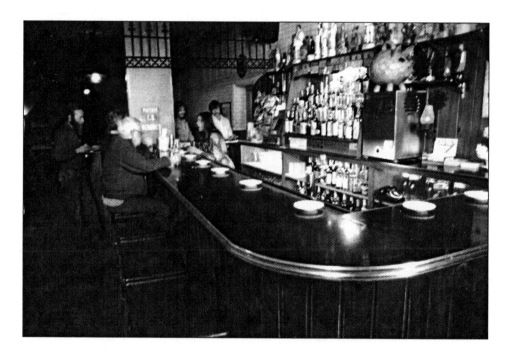

**Claude's Bar, c. 1970. Many a night I stood behind this bar.
Photo by Douglas Magnus.**

Claude's Bar, c. 1970. Photo by Douglas Magnus.

From there I went to Claude's bar, practically next door. It was about four p.m., and there were only a couple of people at the bar. I ordered a beer and added, optimistically, that I was an artist who had just come into town looking for a job and an apartment. This was the luckiest day of my life. Within an hour I was all set. Two guys who were lounging at the bar were both artists who became my friends: Tom Hamill and David McIntosh. The bartender, Jerry, was also a part-time artist and local art critic. He offered me a job bartending during the off hours and said he would train me. A newsboy who had come in out of the rain said his father had an apartment for rent nearby. It stopped raining, and I followed him out. The sunlight on the street was particularly vivid after the shower. We walked about four blocks, up Canyon Road and down Palace Avenue to his father's house. The

father, Canuto, then walked with me six more blocks up Cerro Gordo, a winding dirt street. Canuto's daughter and her child lived in a run down adobe. In the back, with a separate entrance, were two big, unused rooms. There was a stove, refrigerator and sink, but no bathroom. The outhouse was across the driveway. Past it the ground dropped off steeply; there was a terrific view. The rent was eighteen dollars a month including utilities, even gas heat in winter.

Canyon Road at that time was an insular community, where a favorite pastime was watching the traffic trying to go both ways on the narrow, dirty, sidewalkless street. While everything looked run down, there were amenities that are gone now. For instance, Percy's, a tiny store, sold food, liquor, meat butchered while you waited, household goods, and had a gas pump in front. Later it became Plumtree Frame Shop. Within a few blocks were Gormley's, the Friendly Grocery, and the Canyon Road Grocery. Gormley's outlasted the others.

Artists and friends met at Three Cities of Spain (now Geronimo as of this writing), where the owners David and Bob were conversant on the latest off-Broadway play or literary scandal. They also supplied the community with movie classics on Friday nights and occasional live theater.

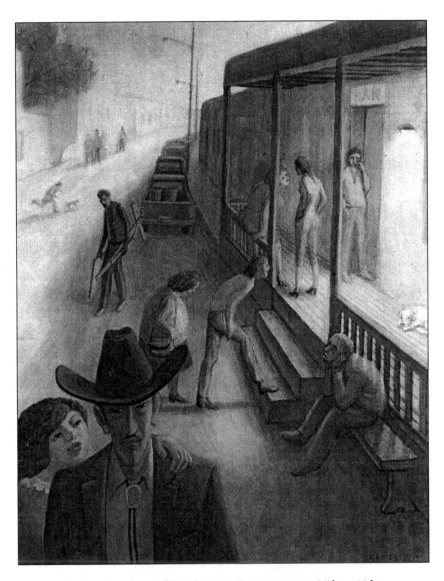

Canyon Road Bar, Eli Levin, 1991, Egg tempera, 20 in. x 16 in.
Collection of Reed and Rubenstein.
This small local bar on the corner of
Camino del Monte Sol became El Farol.

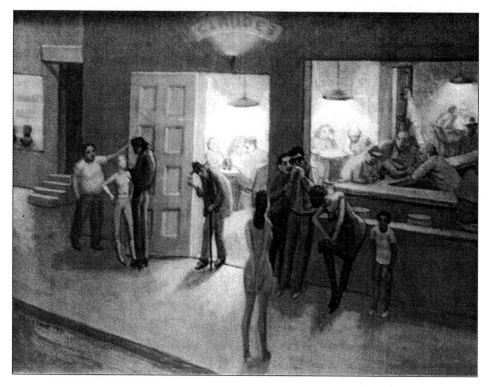

Claude's Bar, Eli Levin, 1991, Egg tempera, 12 in. x 16 in.

At night there was Claude's Bar. Not long before my time, Claude herself presided, turning a roast in the open fireplace and singing French cabaret songs. There had been an unusual international set that later abandoned the City Different. At the time of my arrival, Claude, ostensibly retired, was still very much there, usually at the bar. It was a favorite place for artists' disputes. Hal West was there to shake his cane at "the pretty boys," or sell a block print for the price of a toddy. Later the hippie era brought such renown to Claude's that the city finally had to close it down.

Now Canyon Road is respectable. The little studios have been replaced, with a couple of exceptions, by galleries. But, though art can be big business, one is still confronted with frequent "Out to Lunch" or "Back in Ten Minutes" signs. A shopkeeper is still likely to be an artist willing to share a drink and some good talk. Picturesque adobe haciendas are now built of cinderblock or frame, but there is still a vital art colony. To the artists it continues to be a haven from tension and a place of beauty.

To give a more specific idea of the art scene on Canyon Road, I would like to list the artists I met or heard about. When I arrived there were three who were gone, but were still talked about: Alfred Morang, who died in a studio fire; Olive Rush, whose home is still the Quaker meeting place; and Bill Tate, who had moved to Truchas. The studios open in 1964 included Hal West's, Jim Morris', Agnes Simms', Drew Bacigalupa's, Odon Hullenkremer's, Tommy Macaione's, and Janet Lippincott's. Others, not open to the public, included Fremont Ellis', Eleanor De Ghize's, and Randall Davey's.

Many artists came and went on Canyon Road, some quickly, such as Fritz Scholder and Dusty Rhoades. Others, who remained a few years or longer, included Walter Dawley, Bill Shaer, Sally Kitchens, Ford Ruthling, and John Diehl.

More artists lived close by. On Camino del Monte Sol: Will Shuster, Laura Gilpin, Bernique Longley, and Bill Lumpkins. On Camino San Acacio: Louie Ewing and Eliseo Rodriguez. On Calle Peña: Arthur Haddock. On Garcia Street: John Sloan and Chuzo Tamotzu.

Strolling through the neighboring streets one can still find the studios of Gilpin, Longley, Lumpkins, Ewing and Rodriguez. Newer ones include: Harlan Linzer on Acequia Madre; Forrest Moses on El Caminito; Gene Newmann on Cerro Gordo; Howard Bobbs on Alameda;

Enky Soqween on Camino Cerrito; Dick Thibodeau, Jim Wood, Holly Cary and Geraldine Price on San Antonio; Sheila Sullivan on Johnson Lane, and many more.

Among all these artists and some I haven't mentioned, a few are "known." In the older generation, Davey, Ellis, Morang and Gilpin are perhaps the most famous. Some of the others with a large following include Louie Ewing, Bernique Longley, Janet Lippincott, Bill Shaer, Ford Ruthling and Forrest Moses. Whether the artists are famous or not, I feel that this has been, and continues to be, quite a substantial art colony.

HAL WEST AND JIM MORRIS

I started work at Claude's the first evening I got to town. Soon I knew several artists who had studios up and down Canyon Road. The two most frequent barflies were Hal West and Jim Morris. Jim's studio was across the street from Hal's, but they had a feud going and didn't acknowledge each other. No one knew what it was about. They had come to Santa Fe twenty-five years earlier along with another artist named Chuck Barrows, just after the Second World War. Now they were old and run down. Jerry, the bartender, told me that both Hal and Jim had doctors' orders not to drink. Hal still did, sipping slowly, but Jim never had anything. He just sat there, a roundish, vacuous fellow with a big moustache and sad eyes.

A year later, I had a studio at 616 Canyon Road in the same building as Jim Morris. Our back yards had a low fence between them. He never went anywhere. He puttered around but didn't paint any more. His walls were covered with his old paintings: expressionistic scenes of little stick figures dashing aimlessly about in front of adobe houses or under stormy skies. On the wall near his front door, glued to a panel of wood, was a review of his work from a *Time* magazine of the 1940s. The room was dark. Once I took one of the paintings off the wall to hold it

up to the window. The wall was pale where the painting had hung.

Placid, Jim appeared to have no interests, no women, no visitors. Once, when he saw that I owned a watercolor by Merida, he told me he had lived in Mexico and studied art there, and had known Merida. But he spoke so slowly and lackadaisically that we never pursued the subject despite my interest in Mexican art.

A few years later, I was living on Camino Don Miguel but would often go up Canyon Road. As like as not, Jim would be sitting on a bench by his door, often accompanied by a young red-faced Chicano. This guy was sour-looking, sweaty, pot-bellied, always wearing a wrinkled shirt and loose tie. Something about the way they sat there together made me think he might be Jim's son, but who knows?

There was no notice when Jim Morris died. His paintings disappeared. I've only seen two on the market in twenty years. The Jamison Gallery (now gone) had a good one on loan, though they never hung it. It depicted a face with a crazed expression, backed by a night sky and a full moon. I have the other, a semi-abstract of a father, mother and child all screaming at each other. The Museum of Fine Arts in Santa Fe owns two Jim Morris paintings that they inherited from President Roosevelt's Works Progress Administration (WPA), later named Works Projects Administration. They only showed them once, in a period show.

Hal West was an unpretentiously dressed old Western dandy. As people came through the door at Claude's, especially if it were Jim Morris, he would shake his cane at them. Occasionally he added cryptic insults, spoken to no one in particular. During the winter months Hal and I were sometimes the only people in the bar. He would wager a dollar that a man would come through the door next, or a woman. Either way, he didn't care.

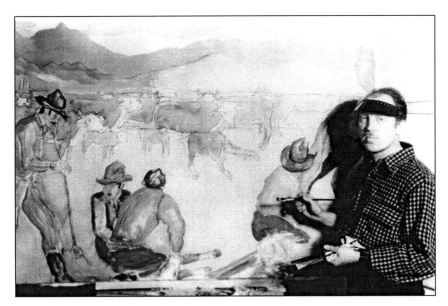

James Morris. Photo by T. Harmon Parkhurst.
Courtesy Palace of the Governors (MNM/DCA), neg. # 73934.

Hal's favorite drink was a toddy: whiskey and water without ice. He'd nurse these drinks for hours.

He often had a stack of prints the size of postcards in his jacket pocket. These were his linoleum cuts depicting cowboy life. Hal sold them for a dollar each or gave them to people who bought him a drink. I bought a few and used them for Christmas cards, as he suggested. His son, Jerry West, now an artist but then a biology teacher at Santa Fe Preparatory School, used to print them from Hal's blocks.

One winter night at Claude's, Hal, Jerry, Hal's son Phil and a younger writer, Bob Wolf, all stood in a row and sang cowboy songs. That was the liveliest I ever saw Hal. Usually he had something of the zombie about him, with those dark bags under his eyes.

HAMP AND JERRY

Claude's was managed by a couple, Hamp and Jerry, characters who had migrated from the underside of Hollywood. Hampton's last name I forget. Jerry was, I think, Jerome LaTouche.

Jerry was tall and sickly thin, his posture slouching, effeminate. He had sunken spaniel eyes, a lined face, a huge Adam's apple and ears that stuck straight out. He was a guileless type who looked like he'd been kicked a few times. Jerry enjoyed telling rambling gossipy stories, heavy with obscure Hollywood references. He was both cook and bartender at Claude's. But it wasn't a popular restaurant. In the kitchen he wrote his art reviews for the *Santa Fe News*, which later became the *Santa Fe Reporter*. His typewriter was on top of the refrigerator. Jerry gave me my first write-up in Santa Fe.

Hamp was the "straight man," very proper, like a butler or an undertaker. He had chiseled features and wore neat, monochrome clothes. He tended to be pedantic, with just a hint of a theatrical false note. In conversation he was condescending and dropped names even more than Jerry did. Hamp officiated over the bar when I worked there, and over Jerry in the kitchen.

They were trying to change Claude's image from a lesbian hangout to a risqué rendezvous for politicians and salesmen, a place they could bring their girlfriends. There was more drinking than sex, more loneliness than partying. The restaurant in the room behind the bar ran a poor second. It was gloomy and dark, heavily curtained, with black tablecloths. As often as not, it was empty. It had the aura of a funeral parlor.

Sometimes I waited on tables. Hamp taught me a fancy way to serve soup. The bowls had lids. I was to lift them off just so, the scent wafting up into the customer's face. Old ladies were served first, then wives, then single women, then girls, then men.

CLAUDE

Ten years earlier, Claude's Bar had been at its peak. A cabrito and a pig roasted on either side of the triple fireplace. But now, during the Hamp and Jerry era, on a winter's night we sometimes didn't even have a small fire in the cadaverous central fireplace.

Claude herself was still quite a presence. She was squarely built, pug-faced, sour, and outspoken. It was said she used to toss out unruly customers herself. Word had it that once she subdued Phil Wilburn, a nasty little artist who knew karate, by putting her cigarette out in his ear.

I worked for Claude for a few weeks as a houseboy. My job was to wake her when I arrived, around noon. Then I was to do whatever chores she thought of. We were getting a guest room ready for her mother's impending arrival, which Claude dreaded. Claude's home was built like a Mexican hacienda, a sprawling adobe house behind a big wall. While it was old and run down, it had expensive touches.

For her wake-up call I brought a double Jack Daniel's on the rocks to her bedside. The two miniature poodles on her oversized bed

would run to the edge and yap at me. Claude would sit up against a pile of pillows and start talking on the phone.

Sometimes, while in bed, she'd receive visitors: elegant types, too. For instance, there was an elegantly done up woman and her daughter, a Radcliffe freshman. Serving the drinks, I was barefoot, for I had had a rash on my feet for weeks that was too painful to wear shoes. I flirted with the young lady, feeling like Li'l Abner. Another time, as I was passing by, I saw the Governor's limousine parked in front of Claude's house.

Another of Claude's servants was a Spanish-American man, about thirty, who seemed to have been in Claude's service since he was a boy. There was a special closeness, as if he were her adopted or illegitimate son. One day when this man was grooming the little dogs, he turned red and blotchy and had trouble breathing. He explained that this always happened. He seemed such a strong, hardy type; it was surprising that he would have an allergy.

Once Claude invited me, and a fat girl who helped sometimes, to stay for dinner. She cooked a gourmet meal, with big thick steaks. Waiting for the food to cook, we drank heavily while Claude regaled us with tales of her life. Meanwhile, she forgot to light the oven. We ate at eleven p.m. Her stories were barely credible, even with the alcohol. She told of a marriage to someone who had a breakdown and attempted suicide in the desperation of his love for her. It was hard, looking at her, to imagine her with a man.

A MEMORABLE NIGHT AT CLAUDE'S BAR

One Saturday evening while I was bartending, things became lively. We had a small Chicano band: an old guitarist, a middle-aged pianist and a young, greasy drummer—probably a family. Before the trio appeared, a tough old lady had settled in at the bar. She wore cowboy clothes and looked even meaner than Claude. Several people acknowledged her, but she sat alone. Hamp whispered, "That's Betty Stewart. Treat her well." When the music started she would occasionally beat time on the bar, like horses galloping.

Three or four couples were dancing. Betty commandeered a natty little middle-aged fellow, wearing a blazer and an ascot. He was smaller than she was. They danced around the floor, too drunk to keep their balance. Something set her off and she flung him across the floor. He crashed into the band, collapsing in a pile of drums. The desultory crowd cleared out while the band righted itself and played on to an empty room. I was supposed to be the bouncer, but I deferred to Hamp's bland officiousness. Betty left docilely.

This scene would have pleased Alfred Morang, whose painting of similar habitués was hanging on the wall across from the bar.

Morang had been a regular at Claude's. He died in his studio behind Claude's Bar when it burned down a few years earlier due to his smoking in bed. His remains were cremated and his ashes sprinkled along Canyon Road.

I was intrigued with Morang's crazy paintings. "Women of the Night," he had called them. Further up the street, in the Canyon Road Bar, there were several painted on the walls around the pool table.

DEANNE ROMERO

I met Deanne Romero in Taos the first month I was in New Mexico. It was Deanne who suggested I move to Santa Fe when things went badly in Taos. A buxom Texas girl, Deanne had an overwhelming presence. She looked like a raunchier Elizabeth Taylor. She was a little overweight and her worst feature was her brown teeth. She said this was endemic in Amarillo, where she came from.

Deanne liked cocktail lounges. She also liked artists. She painted off and on. She was fun-loving, an aimless adventuress, but of course she had a longing to be taken seriously. She had had several marriages and there were two children who were not very much in evidence. Her last husband, Joe Romero, was an insurance man in Española.

Deanne moved to Santa Fe not long after I did. She became popular with our drinking crowd, usually showing up at Claude's or the Plaza Bar with Norma Atencio, a wry little character who worked as a dental assistant. Deanne gave art classes in Española and in Los Alamos. She asked me to take them over, as she was going to try New York. I went with her to an exhibit of her student's work at an

Deanne Conner, c. 1966.

Española bank. The little gathering was very lively and jolly. The paintings were horrible, at least from my graduate school perspective. They were awkward copies of landscape photos from *Arizona Highways*. As we drove back to Santa Fe, I nervously asked Deanne about her teaching methods. One thing she said really struck me: "I suggest that they mix a little yellow ochre in with all their colors."

Deanne went to the big city, where she impressed my father and especially some of his single writer friends. I took over her two classes. The one in Española was at the home of Rosina Espinosa, a woman of classical Spanish beauty. She taught school and lived with her mother. At the end of our final class ten weeks later, we had a little goodbye party. After a few drinks the students loosened up and told me I wasn't a good teacher. That ended that career.

In those early days I was caretaker for a slummy building on Palace Avenue across from the hospital. This gave me a free room. All I had to do was collect the rent from the nurses upstairs, from the big apartment on the main floor and from the men in tiny rooms in the basement. In winter it got cold and dark early, especially in my basement room. I was depressed, lying on my bed. Deanne and Norma suddenly barged in, full of life. They were determined to rouse me from my torpor. Laughing, they threatened to both have sex with me at once. That got me up, and we went out drinking. Over the years this episode became exaggerated into one of Deanne's favorite stories: how she saved me from suicide.

Norma Atencio and Deanne Conner Romero in Juarez, July 4, 1966.

Deanne had many and various proposals from men, including on her trip to New York. She finally married an Army quartermaster named Rex. He was a redhead, younger than she, and handsome in a bland, American way. They moved to Hawaii and have been together ever since. She became a therapist.

LUCILLE HORSLEY

The gallery situation that I stumbled into was analogous to the scene at Claude's: lesbians and artists. The Gallery of Contemporary Art was run by a very spirited woman with short, grey hair: Lucille Horsley. Lucille had a childlike smile that transfigured her dry, wrinkled face. She put her heart into her gallery, infusing it with her enthusiasm.

The two artists I had met at Claude's, Tom Hamill and David McIntosh, were both exhibiting with Lucille. One or two other Santa Feans were in this co-op gallery, while other members were from Albuquerque.

There were few artists and almost no galleries. Some old-timers exhibited at Collector's Corner, which also had antiques and art supplies. Then there was the Shop of the Rainbow Man, whose front rooms displayed Indian crafts while the back room was a gallery of mostly schmaltzy Southwestern paintings.

Horsley's place is now The Bull Ring. Collector's Corner became La Paloma and is now the Nighthawk Café. The Rainbow Man still exists, though no one any longer thinks of it as a gallery.

**Lucille Horsley at the grand opening of the gallery
she helped me put together. Photo by Michael Yesley.**

In her youth, Lucille had danced in the style of Isadora Duncan
and had done concert tours playing a harp and wearing a Greek robe.
Though she had a grown daughter, she never talked about her family.
Lucille did some painting, her style a kind of pop Stuart Davis. She had
tons of art books and magazines. She had been very active in Santa

Fe's postwar art colony. She and all her female friends seemed to have driven ambulances in the war, or at least drove taxicabs afterward. By the time I met her, Lucille had settled down with a square-faced woman, Mary, who had a bureaucratic job in health administration.

It was a great break for me to be included in her gallery, particularly since she favored abstract art and I was doing regional realism. She said it was "good, honest work." In the years since, no gallery showing modern art has shown such open-mindedness toward my style.

Lucille's Gallery of Contemporary Art was large and well laid out, with four or five rooms. It had originally been a stagecoach stop and had wonderful thick walls and old ceilings. Behind another building on Old Santa Fe Trail, it was somewhat hidden from tourists. Days went by without customers, despite being across the street from the Oldest Church and next to the popular Pink Adobe restaurant.

Her artists paid twenty-five dollars a month. If we sold, which seemed unlikely, the gallery took a third. Lucille was always there, presiding over her tiny cultural enclave with a coffee machine, cookies and new art journals. Unfortunately, Mary was jealous of Lucille's time. She thought Lucille should keep their house cleaner and should cook more. Lucille worried and fretted, especially because Mary was putting money into the gallery venture.

Sometimes on Sundays, we artists would visit Lucille and Mary in Tesuque. Their home was up on a mesa and commanded a great view. The driveway was so steep and turned so abruptly that guests parked before the last stretch. The house was sprawling, simple, homemade. Parts were unfinished, other parts already in disrepair.

Years later, when I was doing a stint as an art critic, I was invited to the new home of art dealer Elaine Horwitch. I was horrified to find

myself on the same mesa. Elaine's huge, pretentious, fake adobe house was built exactly where Lucille's house had once been.

During the months I was a gallery member, Mary's pressure on Lucille escalated. Finally they thought that they had found a solution. There was a young lady named Susan who used to hang out at the bar with us. She would run the gallery. We would fix up one of the gallery's rooms as a studio apartment for her, and she would get the sales commissions. Susan was intelligent and attractive: thin, somber and intense, she had a habitual look of slight pain. She had straight, dark hair and wore black clothes. Hamill, McIntosh and I all liked her. We pitched in to fix up her room. I put in a skylight.

Those were happy days for me in the Santa Fe art scene. I had friends who were serious artists. We hung out together at Claude's, showed together at the Contemporary, worked together to further the art scene.

I hitchhiked and rode the rails to New York so that I could be best man at my old friend Bob Cenedella's wedding. After I got there, they postponed the event, possibly because Bob's rich fiancée saw that I was too unredeemably bohemian to do my part at the wedding party.

A few weeks later I was back in Santa Fe and found that Lucille's gallery was closed. Tension had built up between the three women until Mary nixed the whole project. The building was empty, Lucille having taken everything back to Tesuque. Susan disappeared. Months later I saw her at Claude's with Betty Stewart.

I ended up living in the room we had fixed up, surrounded by the big hollow spaces. Years later the space became a famous bar and restaurant, the Bull Ring.

A few years later I was down and out in Taos, trying to survive

a very cold winter. I applied for food stamps. The woman in the office behind the desk was Susan. She gave me the food stamps and I lived on mostly potatoes for a month.

I have a fond memory of Lucille. It's of a beautiful morning in Tesuque, with several of us sitting on her porch. Tom and Dave are kidding around while Lucille, very motherly, is cutting my hair. Wynn Bullock came by; he looked like a crazed Vietnam vet. He laid out a whole row of photos around the balcony, terrific obsessive photos of eroded land.

After Lucille's gallery closed I opened Eli's Gallery at 616 Canyon Road. It was two little rooms where I lived, worked and exhibited, and it was sixty-five dollars a month. Lucille let me borrow lights, shelves, her coffee machine, her mailing list, art magazines, mats and frames. She also gave me an ancient Remington portable typewriter, the same one I am using to write this book.

The first show included Peter Aschwanden, Walter Chappell, Lucille and myself. Thanks to Lucille's mailing list the opening was an event, with old bohemians and new hippies mixing uneasily. The exhibit included a bit of erotic art. Besides my little painting "Three in a Bed," there were some Chappell photos of nudes. Furthermore, in a black case on the table were a series of Chappell photos of his own penis with feathers and other ritualistic regalia stuck on and in it. I thought it was some of his strongest work.

Lucille turned out to have a prudish streak. After the opening she took her paintings down and her equipment back. After that I didn't see much of her.

After Lucille died a young art dealer came to my studio with some paintings that had been hanging in her living room. There was one of mine, a tempera landscape done in Taos. There was also a

Morang self-portrait in oil and a Raymond Jonson abstraction all in greys. He traded all three for an old photo that I had by Tod Webb.

Lucille's own paintings showed up unexpectedly at a benefit sale for the Girls' Club. Little publicized, it was like a garage sale with nominal prices and volunteer women presiding. The location was an empty storefront on Canyon Road that ironically had once been Claude's. The paintings, mostly without frames, were leaning against the walls or on tables. A big handsome painting of a supermarket interior, a bit like Stuart Davis, was priced at eighty dollars. I didn't see any customers. What became of Lucille's art?

WALTER CHAPPELL

Chappell was in some ways an archetype of the new wave of artists coming to town. Walter was around forty, a tall, gaunt, long-haired heavy drinker—a Rasputin. His wife and children were somewhere between bohemian and a sickly, primitive existence. Nancy had gone to a fancy college. She made clothes and did cyanotypes of flower children in robes. Chappell took photos of his family in their naked, animalistic lifestyle.

Early in his career, Chappell was a tyro in the photo world. He ran the George Eastman House in Rochester, New York. Influenced by Minor White, and a Gurdjieffian, he had a following.

At first the Chappells lived in John Sloan's old house on Garcia Street. Later they moved to an old farmhouse in Velarde, north of Española in the Rio Grande Valley. The second house especially was a tangle of valuables and junk. For instance, a grand piano was heaped with found objects, children's toys, photo equipment and so on. It was said that Walter composed music, too, in a special Gurdjieffian style.

All the recently-arrived crazies in Santa Fe were invited out to Chappell's for a day in the country—artists, dopers, spiritual seekers,

Whole-Earthers. His house was surrounded by a maze of irrigated orchards. There were mosquitoes everywhere. We all ran through the humid, itchy undergrowth between rows of trees down to the Rio Grande. Soon we were naked and rolling in the mud, trying to salve the itching. Back at the house, wine, beer and marijuana were everywhere. The guests wandered in and out, leaving trails of mud.

A couple of years later, while the Chappells were in California, the house was burglarized, then trashed out, then burned.

During the late 1960s Walter Chappell and Max Finstein rented a cavernous store on the slummy stretch of Cerrillos Road. They called it "Atlantis Rises," and it became a gathering place for what are now called New-Agers.

Finstein had a selection of poetry books and various alternative publications, and there was mostly psychedelic art on the walls. I went to a few events there. There was a visit from the inhabitants of "Drop City," a commune near Trinidad, Colorado. The name refers to the geodesic domes they built, which theoretically looked like they had dropped out of the sky. There were new ways of doing everything— making houses, growing food, creating energy. All it took was faith, dope and the Whole Earth catalog.

The poetry books, including Finstein's own, were neglected as the visionary ideas were flung back and forth. Finstein became the guru of his own commune, New Buffalo, up past Taos in Arroyo Hondo.

Another Atlantis Rises event featured new art forms developed by a media-obsessed cooperative venture from back East. The leader was a charismatic redhead named Steve Durkee. I can't describe exactly what transpired, but it included flashing lights, repeated patterns,

rotating mandalas and words in acid colors. Soon after this show the group bought a big chunk of property, also above Taos, which became another commune, the Lama Foundation. More recently, Durkee was connected with the Dar-Al-Islam mosque in Abiquiu.

In those days I thought the hippies would manifest a new form of art. I took home a couple of Durkee's psychedelic wheels that said "Yes, No, Yes, No." I hung them in my gallery along with posters from the Avalon Ballroom in San Francisco and from New York galleries featuring pop artists.

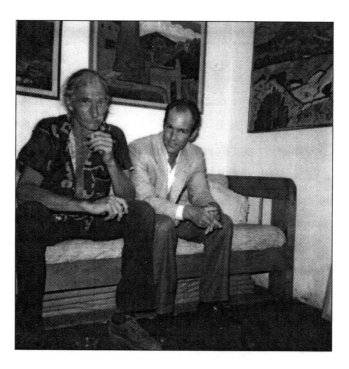

**Walter Chapelle and I at an exhibit of
David Barbero's paintings in my studio.**

I gave a showing of Chappell's "underground" film. The announcement I sent out was a woodcut by Ted Rose, each hand-colored. By then Ted and I had mastered hippie lettering. The film consisted of a lot of disconnected footage he had saved from a failed attempt to do an artistic sequence for *The Sandpiper*, the film with Elizabeth Taylor. Moonlighting with Hollywood equipment, he had filmed a lot of close-ups of woodcarvings of monsters, places among the redwoods and some long-haired nudes cavorting under a waterfall.

WALTER AND TOM

One evening I was sitting in Claude's with Tom Watson, a big, bearded, red-faced guy, kind of a hippie Hemingway. We were at a table that was awkwardly situated between the doors to the two bathrooms.

Walter Chappell came in, agitated, seemingly drunk. He stood looming over us, muttering curses. Tom, whom he was facing, was nonplussed and his face got even redder than usual. "Calm down, Walter; take it easy," he blustered. "Would you like to sit down?"

As Chappell lurched over our table his face showed terrible emotion. He looked like Zarathustra. I had no idea what it was about. I was not even aware that they knew each other—they were such different types.

Walter, shoving Tom, half falling over him, said, "Get up. Stand up." Tom stood, and Walter kept advancing on him, cursing. Watson backed out the door into the street, still trying to quiet Walter. I followed. They tussled, Watson retreating, placating. Unable to look into Chappell's mad eyes, Tom turned and ran up Canyon Road. Walter stood in front of Claude's, gesturing and shouting like a biblical prophet.

Tom Watson, c. 1972.

TOM WATSON

Watson, while he looked like a beach bum, must have had some money. He had a piece of property on East Alameda, a good location that would be worth a fortune today. He took the roof off the adobe, planning to replace it with a cable-suspended contraption. Running into problems with city ordinances, he got discouraged and left the place to molder until somehow he didn't own it anymore.

Then he bought another place near Embudo, on the far side of the Rio Grande. There, too, he began deconstructing the house. He drove around in a Hemingway-style Jeep, bringing heaps of broken-down surplus equipment to the river's edge.

To get to the property he had to cross the river on a platform suspended from bicycle wheel rims running on a cable. This contraption was made by the former owner, a crippled woman. One pulled oneself across, hand over hand. At the low point my behind dragged through the water. Further, I discovered that the wheels could painfully run right over one's fingers.

Tom's hovel was surrounded by techno-junk that he had

managed to ferry over. As time went by, the river did Tom a bad turn, so to speak. It shifted its course, eating away the bank until his property up to the door was gone. This made it necessary to wade out to the hanging trolley.

After the river shifted, a sand and gravel outfit brought their heavy equipment to the other side and began operations. By then Tom was cursing civilization with such vehemence that it wasn't much fun visiting him.

ELAINE CHAMBERLAIN

Tom Watson was large and imposing, although childlike. He was having an unlikely relationship with Elaine Chamberlain. Her husband, the famous sculptor, John Chamberlain, had deposited Elaine and their three boys in Santa Fe and stayed back East to pursue his career. His visits were widely spaced. A religious Catholic, although she seemed thoroughly modern, Elaine accepted the arrangement fatalistically.

Elaine was neat looking, pretty, and managed everything efficiently. She was friendly. Her home was comfortable.

Once in a while she would come down to the Plaza Bar, join our little ragtag bohemian crowd and get plastered. Elaine could curse and make startling blunt remarks. She and I often sat together. A couple of times we got very drunk and went back to my studio together. Both times she woke up at dawn and said, "Oh my God! What am I doing here?" She would quickly dress and rush off without a word. This seemed to work well for both of us.

Her house on Cerro Gordo Road had a huge back yard. She had dinner parties there, and some larger parties, too. Elaine had a quality

of dignity that was much needed in our bohemian world. Later she bought the old Gerald Cassidy compound on Canyon Road. At that time she and an Australian woman ran a little lunch place, Tea and Coffee, that was like an English tea room but with natural food cooking. Her boyfriend was Billy Rodriguez, a macho Spanish cowboy who hung around rich bohemians.

Elaine Chamberlain died suddenly, while still young: they say from a blood clot in her brain. Somehow I came by a keepsake, two santo figures that she had started to carve in wood. There is something poignant in their half-formed bodies.

TOM HAMILL

I idolized Tom Hamill. He was so monolithic. Hamill, who I met on my first day in town, was a close friend for several years. Now we pass on the street as if we don't know each other. Tom had an imposing presence: tall and spare, with a rough-hewn face, he was the archetype of a New Englander. He didn't participate in conversation; rather, he made categorical statements in a booming, stentorian voice. All his clothes were from L.L. Bean, which was not so common back then. He might have been a character out of a Eugene O'Neill play, and he knew it.

Bartending in Claude's one evening, I decided to count his drinks. He had fifteen martinis, which I made very dry and large, and he interspersed them with eight beers. When drunk, he liked to dance. He would jerk around, usually alone, stamping his heavy work shoes and occasionally leaping from a crouching position, like a frog. At the Plaza Bar there was a dent in the acoustical tile ceiling from one of his leaps.

Tom grew up on Cape Cod with his mother. She had known Mary McCarthy and perhaps O'Neill. Before coming to Santa Fe, Tom lived in Truro. He had had some success with his paintings of misty

dunes, almost abstract. In Santa Fe he still painted dunes, taking them back East to exhibit.

His house was back behind Elaine's restaurant. It was mostly studio, off of which was his spartan bedroom. Following the precepts of the New York School, the studio was a very empty room, just a row of paperbacks on the floor along the wall. He would bring in chairs or a table if he needed them.

When visitors came they would stand, while he would ceremoniously bring in and take out his big canvases, one at a time, from a hidden storeroom. Sometimes he eventually produced a few chairs. He was a loner, which added an edge of tension and excitement when he had visitors. The barren room and lack of small talk made one glad if he offered tequila. If he felt expansive, he would offer to bring out some of his early work. These were primitive and somewhat psychotic depictions of weird characters. Tom would darkly hint that these pictures referred to a traumatic experience he had had in the Army, which ended up in confinement and discharge. One didn't dare ask for the details, but rather just waited for each booming statement.

Hamill had difficulty changing the subject matter of his art from dunes to the Southwest landscape. Rocks materialized, but the mist wouldn't disperse. His gallery back east discouraged the transition. This upset him, although he insisted that he painted from higher motives than selling, and he had an income anyway.

In Claude's one night there was a big group of us around a table and I challenged one of Tom's didactic statements. He stood menacingly. I had the brief impulse to grab a chair and try to beat him down, but it seemed too risky so I deferred to his loud opinions. But it rankled, and we weren't as friendly after that.

Women were fascinated by Tom. He was formal with the ladies, like a protective older brother. There was a certain type that fell for him—big, vigorous, highly emotional, good looking but slightly worn. They would hang around him for hours in Claude's Bar until he got so drunk that he would forget they were there. The Claude's crowd would observe with sympathy as each new woman tried to get Tom to bed. We had written it off as a lost cause when a girl named Soulie came along who made the grade.

Soulie was Tom's counterpart down the line—another gaunt New England character from an old family. They were so serious. When Tom and Soulie sat drinking together it was best to steer clear. They stared at each other like big birds in mating season. The scene reminded me of Kokoschka's painting of himself with Alma Mahler in a little barque on a stormy sea. One felt that they could have killed for each other, or killed each other.

After several months, maybe a year, a record for Tom anyway, it all came apart. He hadn't been generally friendly during his romance. After it was over there was a cavernous emptiness in him.

After Tom recovered a bit from the Soulie episode, he formed a dependent relationship with Jack Masters, a retired English colonel from India who wrote *Bwana Junction*. Masters led a weekly hiking group. This group of elderly snobs went on all-day walks through the spectacular countryside around Santa Fe, sometimes as much as fifteen miles. I went along a few times, but found the pace too stiff to enjoy the scenery. Then too, I couldn't crack their reserved attitudes. Tom, more imperious, became a regular.

There was also a men's club along the same lines, "Quien Sabe," into which Tom was initiated. It was supposed to be writers, culture bearers and such. I went once as a guest, or really as the guest of a

guest. I still have a superannuated membership roster on which a colorful old character named Mike Pijoan, noted deaths and other irregularities. At one of their meetings Tom Hamill got drunk and fell into the fireplace, burning his arm.

Masters tried to help Tom sell his work. Even so, as the Santa Fe art world burgeoned, Hamill was bypassed. The years go by and I get an occasional jolt on the rare occasions when I see him coming out of his driveway in the same old station wagon. He still lives in the same house behind where Elaine Chamberlain had her little tea room.

When I first knew Tom he lived all the way down Agua Fria. In Claude's we used to joke about him driving his old station wagon home at night on that narrow dirt road, blind drunk.

That apartment was long and narrow, like a trailer. Tom had a party there for a couple that was getting married: a little Anglo guy named Chris, and a big blowzy Spanish woman named Rita, who had a rose in the cleavage of her bosom. Halfway through the evening she locked herself in the bathroom, with much screaming back and forth as she threatened suicide. The groom went around the back of the house and climbed through the little square bathroom window, saving her.

DAVID MCINTOSH

The other artist I met on my first day in town was David McIntosh, a very handsome fellow. He could have been a male model. He dressed like one, Western casual to perfection. Poised and self-possessed, he spoke evenly and very quietly. I had to lean forward to hear him. His bland face would have just the slightest frown of earnestness as he talked. David was from a rich ranching background, well educated, and had flawless taste.

He painted well—colorful, low-keyed, painterly abstractions. Maybe out of jealousy, we used to repeat in our little circle what Susan said about him, that he seemed to be "screaming under water." David had a way of resting his steady gaze on me as if he saw through me. It made me nervous to be alone with him. Once, when we were alone, he narrated to me in his intense, whispery way a long, tragic story about his first love, a girl back in Montana. It had been a drawn-out, doomed relationship, though what went wrong had a Henry Jamesian vagueness.

McIntosh knew the local VIPs and would often excuse himself

from our company to go chat with them. He had another life of more formal engagements.

There was an older man who lived in Tesuque who was fatherly and solicitous toward David. He would come into the bar, moving unnaturally due to a slight paralysis in his body. His face, too, was somewhat distorted. David seemed homeless, frequently moving, often house sitting some fancy hacienda.

David went to New York to have a one-man show on 57th Street. When he came back he was badly shaken, the only time I had ever seen him so. While he had sold most of his paintings, the dealer absorbed all the money, presenting David with hidden charges. Afterwards, McIntosh fell away from the local art scene. I supposed he didn't paint as much. His work would appear occasionally in a group show.

David McIntosh, 1968.

**David McIntosh, 1965, Oil on canvas, 34 in. x 26 in.
Photo by Tony Kinella.**

At long intervals I would catch sight of him driving his antique European wood-paneled station wagon. Once we had a couple of drinks together. He had begun wearing an eye patch, but not all the time. In his sincere, intense, quiet way he explained that he had a rare disease. No one knew what to do about it. He had to be careful not to use his eyes too much.

THREE CITIES

J ust a block from Claude's was another great hangout: Three Cities of Spain. It was a coffee house in the tradition of Greenwich Village or Paris in the 1930s. It was a gathering place at any time during the day; there was even a reserved group table for the regulars.

David Munn and Bob Garrison, the somewhat unctuous and solicitous owners, were always there. They prided themselves in being the cultural exchange. Dave and Bob had all the local news and even some national gossip. By the door was a table stacked with reading material: the Sunday *Times*, *The New Yorker*, literary and theater magazines. Events were scheduled in the evenings: poetry readings, plays and foreign movies.

I went out with one of the waitresses. The next day I was walking past Three Cities and Garrison called me over. "Just who are you, anyway?" I was lucky that my father was a writer, Meyer Levin, and that Bob had heard of him. After that, I met some of the regulars. Dick Bradford, who wrote *Red Sky at Morning*, was there every day. Everyone was reading this charming novel about Santa Fe then. Bradford knew my father from having met him at a book fair.

I first got to know Kit Blackwood at Three Cities as we were sitting next to each other watching some obscure foreign movie. She had a kind of open house; two of her best friends were an Indian who liked to hunt named Charlie Bird, and a French hairdresser named Jacques.

Most of the waiters at Three Cities were very young men. Many were from high-class local families. I was surprised that their parents let them work there. There was a bit of a decadent ritual atmosphere.

Three Cities hung paintings by some of Santa Fe's more interesting artists. There was a show of big winter scenes by Tommy Macaione—strong stuff. Most people considered Tommy the village nut. While his show was up, he often sat in attendance. Tommy smelled terrible—no one would sit at the nearby tables. Finally Bob and Dave had to banish him from their restaurant. Before that, they introduced me to him. I sat down next to him, despite the odor. He was more coherent than I expected when he talked about art. "It's showmanship. Advertise yourself. Make noise. As Whistler said, 'Wear feathers in your hat.'" I wanted to tell him that he was too good a painter to play the clown, a paraphrase of what Degas had said about Whistler: "He acts as if he had no talent."

After that day, Tommy always recognized me and remembered various paintings of mine that he had seen around town. When I would come upon him painting in the street he would yell to any of the curious bystanders, "Levin, it's Levin, a great artist—Santa Fe's best young painter! He does masterpieces—you should see!"

After Tommy's show at Three Cities, I had mine. I hung eight small paintings on one short wall. They left some Macaiones up in the main part of the room.

I had two particularly ambitious works, scenes of Santa Fe life: "The Sandoval Family" and "The Mariposa Bar." The first depicted a family of eight locals lined up in front of their house, like a group photo. In fact, it was my next-door neighbors, done from memory in cruel caricature. The second, also from memory, was a low-life downtown dance hall full of local types.

One day Bob Garrison telephoned. "Come right over, Eli, there's a couple from Malibu here on a ski trip. They like your work and want to meet you." It was the moment every young artist dreams about. The couple, Barry and Arlene Snyder, treated me to dinner, engaged me in a lot of embarrassing conversation, and bought my two best paintings. It was my biggest sale until then, and for a long time afterward. I thought I had been discovered!

The Snyders and I had a couple of annual reruns of the dinner but not of the sale, and I even visited Malibu to see the paintings *in situ*. Arlene informed me that she had had the interior of their house completely done over; she had switched from Art Nouveau to Art Deco. I couldn't say which was more incongruous for my paintings.

The Snyders divorced, each getting one of my paintings, and the next Christmas season Arlene came skiing alone. She had a suite at La Fonda, and invited me to come up and visit with her by the charming fireplace. Once she got me in there, she asked me to spend the night. Very embarrassed, I declined and clumsily took my leave.

I never saw either of the Snyders again. Recently an art dealer told me that Barry Snyder had been in town. He saw some of my things in a gallery, and said I had lost my talent.

DEAN HOLT

When I was living in Lucille's abandoned art gallery I did Priscilla Hoback's portrait. She thought she was complimenting me by saying I was Santa Fe's second best figure painter after Dean Holt. His painting of her mother was hanging in the Pink Adobe, where I worked as a dishwasher.

Dean was gaunt and earthy, with a hawk-like nose—he looked like a Robinson Jeffers. He had recently had a big art school on the outskirts of town that folded. He drifted in and out of town. He was a terrific draughtsman. Except for the painting of Rosalea, the paint surface in his other portraits was dull. He had a one-man show at Rudy Kieve's short-lived Artium Orbis Gallery: big monochromatic oils of cretinous heads. They were hard to look at.

A few years later, Three Cities heaped mounds of Holt's work on their patio tables. There were stacks and stacks of drawings. This was a one-day sale to help him get out of town. To this day I come across pieces from that sale, usually in the dark adobe hallways of old-time Santa Feans, or in the storage bins of dealers. Some of the little ink studies torn out of sketchbooks, mostly nudes, were exceptional.

Holt himself sometimes resurfaces too: weathered, stoic, drinking at the El Farol Bar (formerly the Canyon Road Bar). On the wall hangs one of his paintings—a wolf howling in the snow.

***Self-Portrait**, Dean Holt, 1965.*

ARTISTS' GROUP THERAPY

In group therapy I found out a lot about the old art colony. Almost everyone in that group had a connection to art. For instance, Janet Lippincott was the town's only abstractionist. Her intimate friend, Margaret Hubbard, was there. Tamotzu's wife, Louise, was there. So was Shuster's widow, Selma. Eleanor de Ghize was herself an artist. I got quite a picture of the old art colony.

Margaret Hubbard had a gallery on Canyon Road called The Barn, but now dealt only Lippincott's work out of their house. She had the insistant rasping voice of an angry drinker. While she was obsessed with Janet, her refrain was that while she lived with her, she was her friend and partner; they were not lovers.

Louise Tamotzu's problem was that Chuzo, a cute little grinning sage, had become senile. He was old and alcoholic, and would not paint. He threw plates at her. With his elegant cane, floppy hat and big sketchbook, he would wander off but not find his way back home.

Shuster's widow was tired of everything to do with him—his art, his posthumous reputation.

Eleanor de Ghize was cowed by her husband, an imperious White Russian. He was a blowhard and she was a genteel hypertensive asthmatic from New England. Her paintings were accomplished, delicate near-abstractions, very refined but sometimes lacking in vitality.

WILL SHUSTER

I paid a visit to Shuster once before he died. I was hoping to use his etching press. He had an imposing compound of buildings on Camino del Monte Sol, with his name in big ironwork letters on the wall. It was a far cry from being one of the "nuts in mud huts." This was the local folklore that passed for art history. A tall, effete man opened the door. He left me standing there and went to fetch Shuster. The enfeebled maestro came slowly to answer my inquiry, and did not invite me in. I explained that I had done a lot of etching and was hoping to find access to a press. "I'd rather lose a leg than let someone use my press." That was it, my meeting with an artist whose work I admired.

Shuster had been a close friend and follower of my favorite American artist, John Sloan. Hamp and Jerry had a couple of Shuster's paintings. One was exceptional; it depicted a tattoo artist in his seedy tattoo parlor, naked to the waist, covered in his own handiwork.

Will Shuster working on Zozobra in 1964. This was the year I met him. Courtesy Palace of the Governors (MNM/DCA), neg. # 29551.

THE SHUSTER ESTATE

At the end of a session of group therapy I approached Selma Shuster and said I would be interested in buying the etching press and some of the equipment. She invited me to visit her and talk. When I went over, we sat down to glasses of sherry. Then she showed me Will's studio, a two-room workshop right next to the main house, visible from the street. "Cinco Pintores" was lettered on the beam under the skylight. I found out later that he also had a large studio behind the house. There were extensive grounds, making it feel as though it were in the country.

The studio looked unused, but the shop Selma showed me was the opposite, as if he had just been there. There were dozens of shelves and cupboards full of intriguing items. Shuster had been a craftsman, a tinkerer. There was homemade equipment, unfinished sculpting projects, painting paraphernalia, many works of art, etching equipment, art books, a box full of journals. A lot of things needed cleaning up and cataloging. The copper plates were in a special box he had constructed, with slits to hold them. Each plate was wrapped in newspaper. This had been a mistake; the newsprint was etching

itself faintly into the faces of the plates. I offered to rewrap them in tissue paper, after cleaning them, but Selma was noncommittal. The paintings were leaning against the wall and against each other. Smaller ones were jumbled on shelves. Selma stepped over a canvas face-up on the floor. "That's a Sloan," she said, leaving it there.

On a second visit, over another glass of sherry at twilight on the back balcony, I offered to straighten up Shuster's things and curate them for five dollars an hour. Selma said she would think about it. She lent me two books that were old, but not valuable, including one on Philip Evergood. A few days later she called nervously to get them back, but there was no mention of the other business.

A few years went by and I had heard no news of the Shuster estate. Then I ran into Selma, who again seemed concerned about doing something. I visited, had sherry. The shop remained untouched, except that the etching press and the art books were gone. I made the same proposal, and again she said she would think about it. She had donated the press to the Institute for American Indian Arts. I happened to know Seymour Tubis, the graphics teacher there, and he said the school had it in storage.

At the time, I was using another press, not a very good one, that I had appropriated from Los Alamos High School. I came across it in a sink cabinet when I was teaching a night class.

I drove out to the IAIA graphics classroom on Cerrillos Road, which was as well appointed as if it were a state university. There were big, motorized presses and state of the art equipment. There was even an elaborate hi-fi suspended behind the teacher's desk. Seymour Tubis said it was impossible to deacquisition anything from the U.S. government. He suggested that I "borrow" it. Shuster's press—

old, small, dirty—had been disassembled and shoved under a table. I brought my old truck around to the back door and we hoisted it into the back.

Then I returned the other press to Los Alamos. Without the excuse of teaching a class to get me into the school building, I felt more criminal than when I had stolen it. I thought I'd busted a gut trying to run down the long hall with that heavy piece of equipment. I put it in the same cupboard I had found it in, and it is probably there still.

TOMMY MACAIONE AND ODON HULLENKREMER

Tommy Macaione's studio was two blocks up from Claude's Bar on Canyon Road, in a little divided building with Tommy on the left and Odon Hullenkremer on the right. Both sides were the same: a small picture window in front next to the door. There were a few square feet of level cement in front of the doors. Macaione was often in front of his door, painting or fussing with his dogs and cats. He would yell out to the tourists, "Macaroni, that's me!"

Hullenkremer, on the other hand, never had his studio open. In the window there was an old painting—a scene of construction workers that looked as if it had been painted in the 1930s in Germany. He went in and out by the back door, then drove around in a station wagon with a fire department blinker on top. It was impossible to imagine this pompous old character chasing fires.

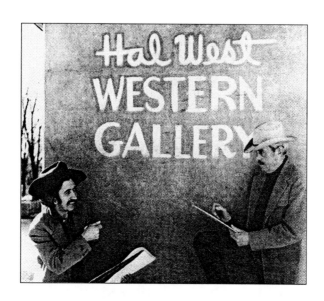

Tommy Macaione and Hal West drawing each other.
From the Come With Me Santa Fe Guide, 1961.
Photo by Michael James.

Odon Hullenkremer.

***Woman with Mantilla*, Odon Hullenkremer.**

His painting style was Manet-like, though dark and turgid like the Munich school. I was impressed with the many Hullenkremers in the lobby and restaurant of La Posada. The proportions were shaky and there was no composition, but the color was resonant. There was a stark presence to his work. Hullenkremer painted more Spanish people than Indians, which was a nice change for Santa Fe. "Two Spanish Girls" in La Fonda lobby was an impressive painting that I liked quite a bit. Hullenkremer and Henry Balink, another German

artist whose works were also on the walls of La Fonda, were there almost every evening. They would sit in the heavy, hand-carved lobby chairs under their paintings.

To the Museum of Fine Arts' credit, they mounted a small show of Tommy Macaione's work that I saw when I first came to town. It was tucked away in an upstairs space. The paintings were vibrant, intense flower scenes in a style reminiscent of Bonnard. The patterns were big and bold, unlike the choppy, harsh, palette knife-hatched jumbles that Macaione became known for.

I'd see Tommy along Canyon Road, painting or walking up the dirt road, surrounded by dogs and cats. He was really a nut, with his tangled hair and beard, his secondhand clothes, his exaggerated gesturing.

The little grocery store across the street, Percy's, had a dog-eared book on the counter called *Come With Me*. On the cover was Macaione, looking surprisingly dapper and Daliesque. This picture book from the 1950s featured Tommy hamming it up in various shops around town, Percy's included.

For many years past, Tommy had run for political office. When Fiesta rolled around there was always a zany "Hysterical Parade," first started by John Sloan in the 1920s. Floats lumbered by, covered with bunting and tinsel, pretty women and mariachi bands. Then came an unadorned flatbed truck featuring Tommy on deck doing a Charlie Chaplin imitation.

I accompanied a friend and her cat to a veterinarian. In the office were four beautiful Macaione paintings that he'd paid his bills with. One depicted himself and his animals walking up Canyon Road, just as I'd so often seen.

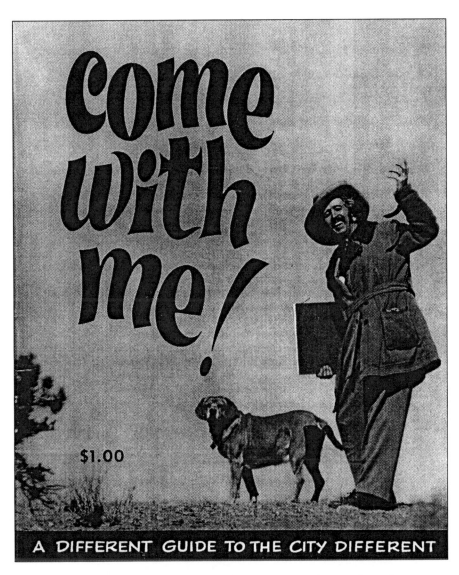

Tommy Macaione, c. 1961. "Where are the other 80 dogs?"
Photo by Michael James.

In 1965 and 1966 I was away from Santa Fe for more than a year. I was trying once again to be part of the art world, first in New York and then in graduate school in Wisconsin. When all this got me down I'd think of Tommy Macaione, painting by the side of the road. He became a kind of idol for me.

When I got an MFA I was expected to be an assistant teacher and stay on for higher degrees, but I decided to come back to Santa Fe. However naïve it was, I wanted to live simply in an adobe house and paint whatever I wanted.

Driving from Madison back down to New Mexico, I stopped on a whim at a gallery in a suburban Colorado shopping center. He must have seen me sneering at the Western art, because he pointed out a dark little canvas, a vague banal portrait. "Here's a gem you might be interested in. It's by Whistler. Have you heard of him … the English artist."

I was struck by the pathetic incongruity then, but this doesn't sound so odd today with Fenn and his peers replacing their tired cowboy and Indian images with even more tired "name" art.

I'd been back in town about a year when I heard that Collector's Corner was having a half-price bankruptcy sale on their art supplies. Before I jumped in with the grubbing artists in the art materials room, I went into the adjoining room to ask Bernie and Bill about some etchings I'd left on consignment with them. Not only had they not matted or framed them, as they'd promised, but they'd lost them. I kept bothering them until finally the etchings did turn up in the bottom of a drawer.

In the art store was Macaione with piles of paint tubes around his feet. He looked up and shouted, "I have to move! Find me a place to live!" The third time he repeated it, I volunteered, "Maybe I can trade with you."

I'd just found a place at 616 Canyon Road, a few blocks down from his place. This space already fit my fantasy of being like him. But now I could have *his* place: my paintings in the left window, Hullenkremer's in the right. Macaione, discombobulated, just kept shouting, "Come see me, come see me."

The next day I banged on his door and he eventually emerged from the mess inside and stood in the doorway surrounded by animals. "They want to kick me out. Me and my babies, my poor little babies."

"I'd like to look over the place." I tried to go in, but the room was blocked with paintings, piles of newspaper, boxes, bags full of garbage, old clothes and rags, animal mess. There wasn't much light. I maneuvered, one step at a time, until I was across the room where there was a short passageway clogged with furniture, including a bed on its side. The smaller back room and the kitchen were impassable, even unapproachable. The stench alone was like a blockade. A kitchen table and stove were barely visible, buried in debris and garbage. I backed out. It could be cleaned out, I told myself.

"I'll think about it," I told Tommy at the door. But I knew I could never deal with it.

There were some old-time Santa Fe businessmen who kept an eye on Macaione. Besides helping him move when the landlords couldn't take it anymore, they'd occasionally clean him up and, if needed, get him medical care. This time his mentors moved him to a nice little house on the corner of Acequia Madre and Martinez Lane. It had a back yard that they enclosed in chicken wire for his dogs and cats. Macaione lasted several years there, running the place down, before he moved to Ephriam Street off West Alameda.

At Ephriam Street, Tommy's living conditions got seriously out of control. He had over seventy cats and dogs, many with diseases. The neighbors petitioned. Tommy battled with city officials and even went to jail. The local newspaper went wild.

I paid a visit to Tommy on Ephriam Street. My girlfriend, Maria Martinez, wanted to write an article about him. This was before the animal wars. I thought I'd use the visit to try to talk Tommy out of a painting or two. After all, wasn't it common knowledge that he traded paintings for dog food?

We did get the story and the paintings. Tommy gave two paintings to Maria and the third I bought for two hundred dollars. But it wasn't easy. The day was cold, and Macaione's place was dark and dank, with all the windows boarded up. Like his last place, the back yard was chicken-wired but this time even over the top. I left the front door open, hoping to see inside. There was no light and no heat. The interior was moldier than the previous one.

While I stumbled around, Maria interviewed Tommy in front of the house. He kept casting worried glances back at the door, as if I might damage something inside. I expected more paintings. I penetrated to the back of the room before my groping encountered a stack of flat shapes against the wall. I could just distinguish cardboard, glass, broken frames, boards. Every time I pulled something loose and struggled back to the door where I could see it, it would turn out to be a board used as a palette, a blank canvas, or an abandoned effort to depict a cat or a dog or a garish misshapen flamenco dancer. Where were the big flowers, the vivid landscapes?

I'd come out every few minutes to take deep breaths of the fresh air and show Tommy some wretched daub I'd retrieved, saying, "What about this one?"

"No, that's a portrait of one of my babies, a memento," or, "I need to work on that." Back in I'd go, with Tommy looking worried that I might hurt one of his cats or dogs. By the time I extricated three small landscapes, Maria had gotten plenty of material in her interview. The paintings were unsigned. Maria and I stood there shivering while Tommy ducked into the house and eventually reemerged with a brush and a tube of orange paint. He scrawled his name across the backs. I gave him the cash and we took off.

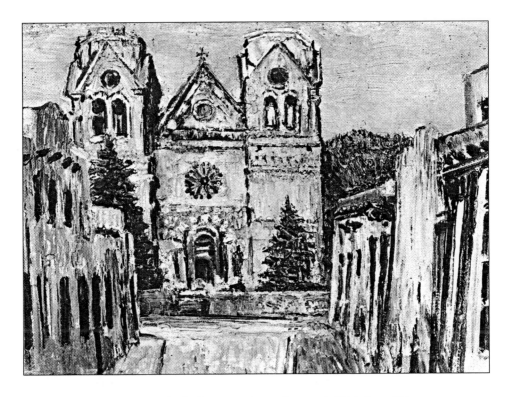

St. Francis Cathedral, **Tommy Macaione, nd, Oil, 14 in. x 18 in.**
From 50 Years of Santa Fe Realists.

Macaione at 83.
Photo by Laura Husar, published in *The New Mexican*.

Maria wrote what we thought was a sympathetic interview. It had more facts and less crazy-old-character stuff than the usual articles. The *Santa Fe Reporter* published it.

Macaione telephoned repeatedly and raved incoherently. Sometimes he'd plead with us to invest in a painting he hadn't done yet. We could get together a group of investors. He needed to take care of his family (of cats and dogs). Other times his tone got belligerent, and he'd shout that we cheated him out of his pictures. At his worst, he raved that Maria had implied he was a homosexual, because she'd quoted something about his loving animals, rather than having women friends.

LOUIE EWING'S MACAIONE STORY

I never tired of hearing Louie tell this story. Just imagining Louie, who was such a careful craftsman, in the same room with Tommy made me laugh. Macaione kept inviting Louie over to his place for tea. Ewing would make excuses, but finally, hating to equivocate or be rude, he accepted. This happened long before my time, but even then Tommy's slovenliness was notorious. His saucepan and cups were in the sink, dirty, with all his other dishes. He pulled them out and heated some water.

"Do you want some crackers with your tea, Louie?"

"If it's no trouble."

"Oh, I know those crackers are around here somewhere." Tommy rummaged around, finally throwing a heap of clothes off his bed and looking in the pile of blankets. No luck. He lifted the sheets. Aha! There were the crackers. He gathered them up, put them in a bowl, and passed it to Louie.

MORE ABOUT HULLENKREMER

After Odon Hullenkremer died I saw many examples of his work on the market. I wonder what became of the good ones.

I had a memorable dream about Hullenkremer. I was in his studio, though in reality I had never been there. He was showing me his many neat racks all full of paintings. I was overwhelmed with a sense of oppression. The paintings were lifeless, and the studio reeked with futility.

Hullenkremer's estate surfaced at the McAdoo Gallery. They half-heartedly produced a show, not good work and not a successful show. After that they would hang a few paintings, but the bulk of his work remained in a shed behind the gallery. A friend of mine who worked at McAdoo Gallery, Gene Cluster, let me into that big storage bin. Though it was cold and only dimly lit, I spent hours rummaging. The works looked more dated than I had remembered, a kind of turgid calendar art style. There were many stereotype portraits, mostly unfinished. I pulled out two little oils that the appraiser had marked ridiculously cheap, under a hundred dollars each. I bought them, but even after I cleaned them and tried to live with them, I couldn't shake the feeling of emptiness they projected. I traded them off.

PETER ASCHWANDEN

Aschwanden was a shadowy character, a romantic wanderer who had a mythic reputation. I had often heard of him but it was a long time before I met him. A handsome redhead, he had lived at 616 Canyon Road before I did, and had a beautiful girlfriend with long, auburn hair. After they broke up, she joined a commune near Cerrillos where members were given new names. Hers was "Go-Go."

She told me that Peter often went down to the Santa Fe River, a block away, and sat there dreaming. "We called that spot 'Aschwanden Falls.'"

I saw one of his canvases in the storeroom of the Pink Adobe when I was washing dishes there. Unfinished and murky, it depicted a dark figure going down a country road under a full moon. It had something—a sense of murky wanderlust.

One day Aschwanden showed up in my gallery. I made an effort to draw him out. He came back another time with some ink drawings he had done while living in a slum apartment on the lower east side of Manhattan. There was a bleak angst similar to German expressionism

about them. I offered to show the drawings. We hung two rows along the wall next to the door. They were good, but nothing came of it.

Peter Aschwanden.
This photo was taken in Pilar
by John Muir the year of the Watergate hearings.

Some years later I saw that he had done the illustrations for *How to Keep Your Volkswagen Alive: A Manual of Step-by-Step Procedures for the Compleat Idiot.* I heard he was living in El Rito, which was then a New Age outpost led by the visionary Peter Van Dresser. Eventually, the local people burned them out.

Canyon Road Kitchen, Peter Aschwanden, 1965, Ink on
paper, 12 in. x 18 in. Aschwanden had an exhibit of this and other ink
drawings in Eli's Gallery, 616 Canyon Road, which had previously
been his studio. Despite the title, I suspect the drawing actually
depicted a New York kitchen. Photo by Bob Nugent.

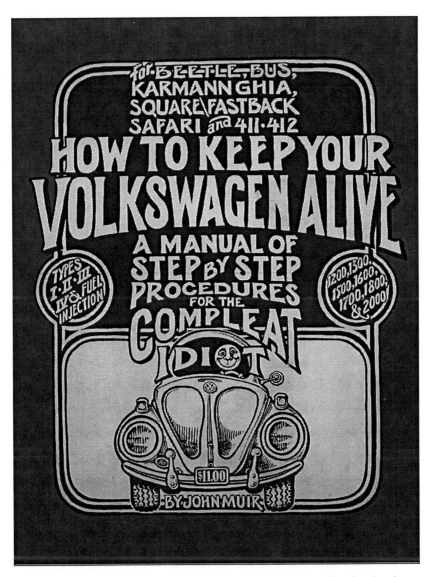

Peter Aschwanden did the cover and illustrations for this book.
Published in 1969, it went through nineteen editions
and sold about two million copies.

FORD RUTHLING

F ord was a native Santa Fe Anglo, a rare breed. His mother owned Doodlet's, a crazy store similar to a German children's nursery but gone off the deep end.

Ford, tall and unusually handsome, told me that he had a twin brother, but I never met him.

Ford prided himself on his old-master style of drawing, somewhat Dureresque. He did painstaking renderings of birds, nests, bugs, leaves and so on. I showed him how to etch. He liked the process and did several plates, hiring me to edition them. His first effort had in it all the aforesaid items and speckled eggs, too. It was a big success. We editioned fifty. They all sold, mostly through Doodlet's.

I wiped that plate fifty times, a numbing process. I had to finesse, leaving a little extra ink in the nest and wiping the tips of the leaves extra clean. I delivered the prints to his home, which at that time was nearby behind Eleanor Bedell's antique shop on Canyon Road. Behind her building there was jungle of antiques, on her back porch, in her patio, even under Ford's portal. Bedell was his landlady. Ford's place had a row of windows and French doors in front.

One day I was walking down Washington Street when he pulled up in a car he'd just acquired, a refurbished 1950s maroon colored convertible with black leather seats. "Want to take a spin?" I got in and we cruised around the Plaza. I admit I was somewhat embarrassed.

On another occasion I was having a happy hour drink at the Plaza Bar. The bar phone rang. The bartender, Ted Ipiotis, called, "Eli!" This was a surprise. It was Ford. I asked how he could possibly know I'd be at the bar. "Oh, I just knew," he said. This was the first time it dawned on me that I might have a drinking problem.

Ford had called because he remembered having seen a painting of mine of a sea bird on a beach. I'd done it in Boston in a faux-primitif style, egg tempera on a rough old board. The bird's eye was painted over a knot in the wood. Ford said he knew a lady who loved sea birds. She'd surely buy it. He asked the price. "Oh, I don't know, how about seventy dollars?" The next day I left the painting with him, and she bought it. I was pretty happy. Twenty years later, a friend of mine who worked at Fenn Gallery told me they had something of mine in their bins. There it was.

Ruthling once did a strange round painting of Adam and Eve, a commission for La Fonda Bar. His big claim to fame, however, is a set of commemorative U.S. postage stamps depicting Indian pottery.

Betsy's Harvest, **Ford Ruthling, 1973, Oil on canvas, 48 in. x 60 in.**
Photo by Ford Ruthling.

TED ROSE

Ted was a big-boned, slow-moving fellow. He was good with his hands, and a steady worker. When I had Eli's Gallery he joined me in doing graphics in the back room (which was really the kitchen). We printed woodcuts and etchings on a homemade press, an oak frame built around some surplus rollers.

Ted Rose at the Grand Opening of Eli's Gallery, c. 1967.

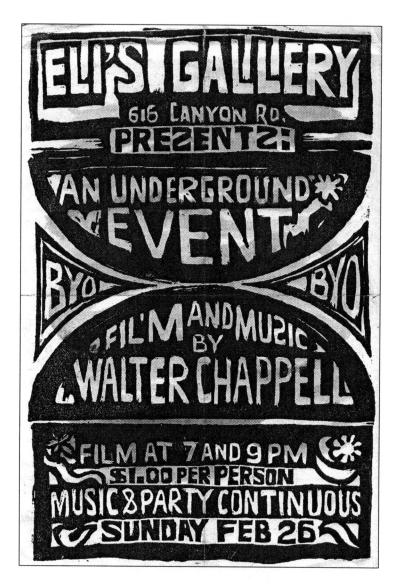

Ted Rose's first woodcut poster, 1967.
Notice three of the six S's are backwards.

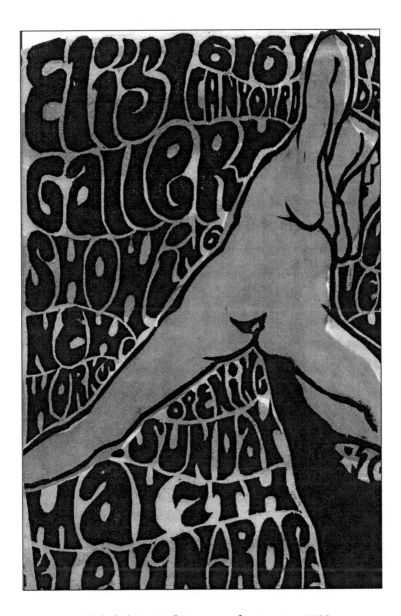

A slightly later Ted Rose woodcut poster, 1968.

Ted's art at the time was an emotionally opaque variation of Edvard Munch. He did some handsome color woodcut posters and an outsize menu for Three Cities, which was gorgeous and took weeks to cut but which was done in illegible hippie lettering.

In the winter months Ted was caretaker for an estate in Tesuque. It was only active during summer months, a home for retarded children. Many a cold night Ted and I sat in the enormous main room in front of a roaring fire. In this romantic atmosphere we took to hiring a model named Polly. We drew her warming herself. Eventually she became Ted's wife.

Ted worked there when the kids were on the premises, too. He and I were walking through the Plaza one day when I saw, lettered on the side of a van, "God's Little Angels." Suddenly the door slid back and the children piled out along with their guardian. Most of them had oversized heads and ill-fitting clothes. When they spotted Ted they came scrambling over. "Ted! Ted!" they chanted, circling and hugging him.

Ted and Polly built their house just down the street, at about the same time I built onto mine, adding a kiva studio and second floor. While not as original as mine, their house was sure built better. Polly did the traditional mud plaster walls inside. They even poured mud floors, devising an ingenious way of sectioning to avoid cracking. My own attempts at mud floors were less considered, and ended up hidden under flagstone in one room, bricks in the other.

Ted built a studio next to his house, where he pursued freelance commercial art. He won a prize for the year's best poster. It wasn't a woodcut.

In recent years he started painting again. Almost every watercolor he does has a train in it. They're perfect, accurate as photos

and beautifully rendered. He had worked for the Chama narrow gauge before I met him, and had been a switchman for the Chicago & North Western. I hadn't known that Ted had an amazing ability with watercolors that he totally repressed when we worked in the print shop together.

STEVE CATRON

Steve Catron was an innocent-looking young man. Steve came from an illustrious family but he seemed disconnected. He would stand around in the most nondescript clothes, slightly dazed. When I first knew him he rode an old green bicycle. He lived with his birdlike mother and hardly seemed to have relationships.

Like an alchemist, tucked away in a studio that had been his father's work shed, Steve labored over a series of drawings, elaborate renditions of tortured little people and paraphernalia in a claustrophobic tangle of walls and streets. His drawings were on a tiny scale, and he was secretive about them. Obsessive, he refused to show his work to anyone, and always said he had destroyed it. Rarely, in a benign mood, he would give a glimpse.

Before he developed this fantasy work, Steve and I used to go out sketching together. But just when his drawings of buildings and landscapes were getting exceptionally good, he stopped doing them.

One of the few native Santa Feans in the art scene, Steve Catron felt strongly about the city itself. A project he often contemplated was to draw all the buildings up one side of Canyon Road and down the

other. He wanted to string them out on a scroll that would reel across a viewing box, as was done in the nineteenth century with a view, for instance, of the Mississippi River.

Catron was very disturbed by the changes in Santa Fe. He could remember hunting rabbits behind his house on Bishop's Lodge Road, and ice skating downtown when the city fathers would block the river to create a little frozen lake.

Toward the end of our sketching days we tried something different. Along with Catherine Ferguson, we drew a view near my gallery: the overgrown field, a wall, some little adobes beyond, then trees and mountains. We three sat chock-a-block and drew the same view on the same sized paper. Then we cut our drawings into little squares, interchanging various sections, thereby making three composite versions of the scene. We each kept one, though probably they're all lost now.

When I converted my kitchen at Eli's Gallery into a print workshop, Catron, about twenty, used to hang around. He was a whiz at hippie lettering. Catron and Ted Rose and I thought that psychedelic art was a new movement. We tried to incorporate its vibrating colors and art nouveau shapes into our work.

Then Steve went to San Francisco and stayed there for five years. He retouched photos for a living. I could imagine him leading a totally subterranean life, lost to the world in some moldy rooming house. He amassed a collection of miniature Avalon Ballroom posters. He even designed a few concert posters, a beginner at the end of the scene. Steve returned to Santa Fe looking washed-out.

In the early 1970s, when I began to build my studio, Steve Catron would bicycle over almost every day and help. Much to my surprise, his otherworldliness did not interfere with his being a very practical

worker. He was better at construction than I was, and a hard worker, too.

We dug out the foundation, a strenuous task that took weeks. The back of my lot was higher than the front. This required a five-foot-deep footing. Toward the back we hit a concrete slab about four by four feet, with a hole in the center. We were trying to smash it up with a sledge hammer when a stupendous odor rose up, sending us running. After the smell dissipated, we poked delicately around. Under the chips of concrete and loose dirt there was a pit filled with wine bottles. Their caps were rusted and there were no labels. Inside them was urine.

Steve went off to find some cartons while I slowly and carefully extracted the bottles, about twenty of them. We loaded them into the trunk of my car and took them to the dump. As we drove down Palace Avenue, we joked about flinging the bottles like Molotov cocktails into the Fine Arts Museum and the Horwitch Gallery.

Steve helped me put together a small adobe-making frame. We used it for over 2,000 adobes. We dug a shallow pit in the front yard, filled it with water and shoveled in dirt. We had plenty left over from digging. Then we threw in a bit of straw and hoed the mess up. We shoveled this heavy mud into the form, packed it down, and then lifted the form off. The brick would keep its shape. We put the form next to it and packed it again. Slowly, the yard was covered with drying mud bricks.

I began paying friends and acquaintances to help. Steve and I borrowed a truck and drove down to Sears, where we bought their cheapest cement mixer. While we continued to make the adobes from a hole in the ground, we used the mixer to make the mortar, which

was thinner. We had contests to see who could make the most adobes per hour. There were now two mud holes, with a barefoot friend stomping and sloshing in each—this was the easiest and fastest mixing method. The record was twenty-five adobes in an hour.

Untitled, **Steve Catron, 1969, Colored pencil, 11 in. x 8.5 in.**
Steve did this drawing while we were building the first floor of my round studio. The apricot tree on the left still lives.
We were making adobe bricks in the yard.

The construction work was going faster than the adobe making, so we started buying adobe bricks. Some hippies who lived up in the mountains were tearing down old walls (from who knows where) and hauling the bricks in a derelict station wagon. On their last delivery they drove up backwards, then pushed the vehicle around by hand and left in reverse.

Catron worked along with me in the increasing chaos of hiring helpers. He helped me add door and window frames to the rising walls. We added to our equipment a table saw from Big Jo Lumber. Steve and I made countless trips to the Rios junkyard, just three blocks away, for vigas and beams, windows and doors. Steve refused my offers to pay him, saying that it would make him feel obligated. But he continued to show up at about ten every morning, riding his green bicycle.

Our best helper was Roxanne, a 28-year-old former nurse from Carlsbad. She was very prim, and when she admitted to being a virgin, we teased her mercilessly. I would not have been surprised if Steve had been one, too. She kept the cement mixer as clean as a bedpan. There were other women on the job, too. I found they took orders better than men.

Roxanne was house sitting for an old artist named Agnes Tait, who was in Spain. Tait specialized in children's portraits and paintings of cats. Tait's own ancient cat, which was reputed to be twenty years old, had been left in Roxanne's care; Roxy got fifty dollars a month to look after it. But the cat died. Roxy was very upset, and Steve and I humored her, promising a burial ceremony. We dug a little grave where we were going to put the inside stairs. At sunset we laid Agnes' cat to rest, covered it over and drank a toast.

The next day we started the staircase, which was to be solid adobe so that it would also buttress the curved, two-story wall. We

Me in the doorway of my unfinished studio, 1969.
Note the bad luck horseshoe.
The unfinished staircase is in the background.
Photo by Janet Mendelsohn.

heaped a huge pile of dirt and broken adobes over the cat grave, shaping the mound to reach up to the balcony. Unfortunately, that night it rained. The dirt melted and spread halfway across the site. The next day we shored the pile up again, and again that night it rained. Three times this happened. We finally got the staircase to stay there and it looked very organic. It is still my favorite part of the house.

On Halloween we finished the floor of the balcony just as the sun was setting. Our crew included Steve, Roxanne, Cathy Ferguson, and a

big blond kid who was the adobe-making champion. He often mixed empty beer cans into the adobes. We turned up the phonograph full blast. The adobe kid loved one particular record, James Moody, and played it over and over. We were all tipsy. The rain came down lightly as we danced on the new deck. It was a moment of elation.

As the walls got higher, Catron began to worry that the studio wasn't structurally sound. He expected the second floor to collapse. After our ecstatic evening, Steve said he would not go up there again. He never did; he stopped coming around.

He began hanging around with other artists who were more abstract: Gene Newmann, Frank Ettenberg. He began to paint more than draw, experimenting with color patterns, grids and charts. Even his grids of color, which I saw on one of the few occasions when he agreed to show me his work, retained his remarkably sensitive touch.

Catron finally began to exhibit, influenced by the aggressive professionalism of Ettenberg. Steve had a one-man show at a glossy new gallery on the corner of Marcy and Lincoln that was run by Robert Israel, a gigolo-looking fellow who drove a Bentley. I was disappointed in Steve's paintings. I thought them eclectic, which, I suppose, means influenced by artists other than me. That year the Museum Biennial included a drawing of Steve's, a neighborhood scene full of crazed people and wild dogs. The house in the middle of the picture was mine. I bought the drawing.

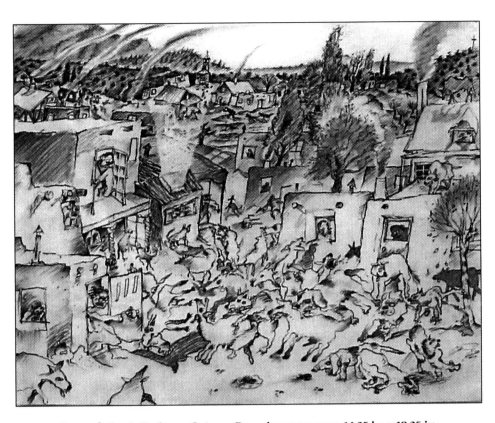

Perros de Santa Fe, Steve Catron, Drawing on paper, 14.25 in. x 18.25 in.
There were many barking dogs in my neighborhood.
Steve's drawing depicts my house and studio on the left.
That is me peering out of the door on the second floor.

PHIL WILBURN

As I was walking down Canyon Road, I noticed that someone was opening a new shop across from Three Cities. The door was open, revealing a long room with windows all down the right side. There was a short fellow with a crew cut, who looked like a Vietnam vet, hanging large paintings along the wall opposite the windows. Some were a bit like Lichtenstein, with violent comic book images; others were more abstract. Someone I knew was also there, and he introduced me to this new artist in town: Phil Wilburn. I forget the context, but Phil recited large chunks of Dylan Thomas and Shakespeare. Phil had quite a stock of anecdotes about famous contemporary artists.

**Phil Wilburn at Eli's Gallery
Grand Opening, c. 1967.
Photo by Michael Yesley.**

Untitled Painting, **Phil Wilburn, 1965, Oil on canvas, 60 in. x 80.5 in.**
"When you buy it I'll give you the title."

Wilburn fell in with our drinking crowd. He was handsome: a smaller, coarser Paul Newman. But when Wilburn was on a binge he would hang around for days without inserting his front teeth.

He came from Detroit, where he had apparently been the young tyro in the art community. Somehow he arrived in Santa Fe with enough money to buy an adobe house on a hill overlooking Cerro Gordo. Phil's wife, Shirley, had long, straight, blond hair and a gaunt, attractive face. She looked like a hillbilly. They had two small children.

We hardly ever saw Shirley; she worked at the Highway Department. On the few occasions when she was present, she was quiet, deferring to his opinions and praising him. Wilburn said his father had been destroyed by the Mafia. There were dark, poetic allusions to horses, bankruptcy, suicide.

Wilburn was completely professional in art matters. For instance, he made his own stretcher bars, ingeniously fashioned by slicing four-by-fours in triangular sections. Phil was also obsessive about Tai-Chi. While paying lip service to its peaceful aspects, he managed to give it a threatening, macho tinge. In the Plaza Bar he would say to newcomers, "Give me your hand, I'll show you something." He would jab the fleshy part between forefinger and thumb, causing a paralyzing feeling.

Another karate incident: Gene Cluster and Anne Sawyer, recently wed, were strolling up Canyon Road. They saw Phil Wilburn coming their way and greeted him. For no apparent reason, Phil gave Gene a karate kick in the stomach.

On one of Wilburn's many interminable visits to my studio, he made the pronouncement that my paintings "had Chi." This was apparently his highest compliment, but it irritated me.

A good-looking, young, waspy couple joined the gang at the bar. Sometimes they came in together, sometimes separately. Both exuded sexiness and dissatisfaction. She was a teacher; he said he wrote. At first they lived on Canyon Road in a big studio that the Opera used in summers for rehearsals. I remember a party they had where someone got drunk and fell on a coffee table, causing a mess. One evening the wife came into the Plaza Bar with a black eye. She cried and I listened to her troubles. Her husband had left her. After a few drinks we went over to her place, a quaint homemade adobe on Cerro Gordo, hidden

in the side of the hill. Over the bed, just above the pillow, there was a dent in the wall where her husband had swung at her and missed. We started a relationship. A few nights later I walked into the Plaza Bar and saw her sitting on Phil Wilburn's lap. He lasted longer than I did.

Wilburn had a painter's block. He would walk all over town, or sit listlessly in other artists' studios for hours. Several artists had work spaces on the second floor of the Plaza building where the Ore House is now. There was Paul Kinslow, who painted snow-capped mountains; Shaughnessy, who did portraits on the Plaza; David Barnett, poet-turned-jeweler; and myself. Phil Wilburn came around almost every afternoon. All this time, though he didn't admit it, he had been making one final effort to paint, to do his masterpiece. He worked sporadically at this big canvas for a year or more, and did succeed in finishing it. While it was flat and symbolic like his old style, with outlined biomorphic shapes, this new work was more naturalistic. It was a symbolic self-portrait, with surrealistic sexual details.

HUGH HUDSON

Reminiscing about Phil Wilburn brings to mind Hugh Hudson, who Phil used to refer to as "an ex-has-been."

Hugh was tall, with a sunken face, dark crooked teeth, bugging eyes and a balding pate fringed with scraggly grey hair. He looked a little like the famous art critic, Clement Greenburg.

Once a hopeful Santa Fe artist of the silent generation, Hugh had gone to seek his fortune in New York. He hung around the second generation Abstract Expressionists. Hugh regaled me with stories of New York bars and buddies. I was a captive audience in my gallery. He drank my beer, my wine and finally my special occasion whiskey while he exuberantly praised my paintings, insisting that I had to have a show in New York.

"I can arrange it. Have you ever heard of Ivan Karp? No? My God. O.K. Harris? No? Well, Ivan listens to me!"

Hugh worked himself into an agitated state reminiscing about his long lost connections. He said he was calling Ivan and told the operator it was collect. He continued his haranguing over the phone, mostly about himself, but throwing me in as a fellow misunderstood

artist. I was dumbfounded that a New York dealer might actually be on the other end of the line listening to this extended rave collect. Whoever it was, perhaps really Ivan Karp, he hung up. Hugh blustered a few minutes, collapsed on my studio couch and conked out.

The next day when I opened the gallery it was hard to get him to leave. Luckily I was out of liquor.

Occasionally I'd run into Hugh both in New York and Santa Fe, at artists' bars or openings. He'd glare at me and I'd glance away. I've never come across a painting by Hugh Hudson.

CAROL MOTHNER

Carol Mothner and I first met at Jamison Gallery. Margaret Jamison had practically the only gallery in town in the 1960s. Though Margaret was overwhelming in her loud Texas way, she was sympathetic and hung one or two things by Carol and me, usually in the basement showrooms. Carol had one painting in particular that I never liked. It hung at one time or another on every wall in the gallery. A slapdash evocation of long-stem flowers in a vase, it reminded me of the art I used to see in Greenwich Village boutiques.

Carol Mothner was cute, but high strung and aggressive. She was quick at repartee, her voice sharp. I felt mawkish in her presence. We moved in the same circles. Her paintings improved. The colors got lighter, the strokes more sensual. Her style shifted from Daumier-like to Corot-like. The drawing was clumsy, but no one seemed to mind; Carol's work was popular.

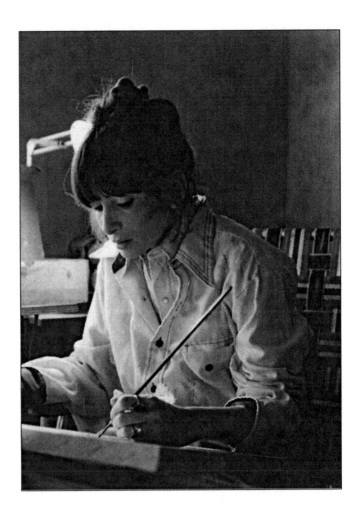

Carol Mothner, 1979.

FENN GALLERIES

Carol and I were both infatuated with Fenn Galleries when it opened. By then, Margaret had sold Jamison Gallery to Zeb and Betty Conley. Carol and I hung around Fenn's, discussing the pictures with the staff or with Forrest Fenn himself. There was a mesmerizing aura of big money and, besides big name western artists, a number of marginal paintings by famous artists.

Fenn came up with a Modigliani portrait. Carol and I tried to analyze the style with the help of her Modigliani book. Was it a fake? I thought so. The brush strokes were too uniformly lush, without linear passages. Forrest Fenn was touchy. He bluffed, and we just said, "Yes, yes, yes." He enjoyed talking to us. Carol was so attractive and intent, and I was writing the art column for the *Reporter*. Most of Fenn's clients were from Texas. He felt estranged from the locals, and perhaps we helped fill that gap.

The local artists that Fenn showed were retired advertising and illustration men who had turned to Western subjects. Anything on Fenn's wall had its own little clamp-on light and a price of over five thousand dollars.

We dogged Forrest Fenn assiduously and listened obsequiously until he finally made a noble gesture that would undermine local criticism and placate the jealous art community: he'd sponsor a local art exhibit, a group of Santa Fe realists. Could I get such a show together?

Could I! Our big chance had come. This sanctum sanctorum would be ours, with its tile floors, horno fireplaces, Indian rugs, little light fixtures attached to every gilt frame. What about the entire wall that was covered with famous artists' palettes? Would ours be there someday, along with those of Nicolai Fechin, John Sloan, Eric Sloane, Paul Pletka?

Fenn offered to call a press conference, throw a swank opening, give out awards. The only catch was that the show would only be up for one weekend, two days. His wall space was too precious for more time.

In Taos there was a group of young painters, the "Taos Six," who were commanding a lot of attention. They tried to paint like the old generation of Taos artists. I called our group the "Santa Fe Six." But which six? Of course there was Carol Mothner. Then my painting companion, Louie Ewing. Louie was our mentor, our link with the old Santa Fe art community.

Next I chose Ralph Leon, who had moved to town recently. He was a little older than I, and also painted in a 1930s style. Ralph had lived in New Jersey. He painted old derelict buildings and the amusement park in Atlantic City. He was having trouble adapting his style to the Southwest. He went out of his way to find old brick buildings such as those around the old Plaza in Las Vegas, New Mexico. It bothered me that he worked from photos, but he painted at night, as he held a full-time job doing graphic design for the Bureau of Land Management.

My fifth choice was Catherine Ferguson. Her style and mine were similar, except that hers was bolder, sloppier, more expressionistic. She

was more inclusive in her subject matter, throwing everything into her pictures, almost primitively. She got me to go out and do watercolors while I showed her how to do egg tempera. Cathy's work was probably the least likely to appeal to Fenn and company. The paintings were in poor shape, on cheap materials, unfinished, damaged. Some she had discarded, others given away. I chased around to find them. Most were in Galisteo in the home of her ex-boyfriend. Catherine was a good artist, vital rather than glib. Her very awkwardness gave me an added incentive to include her.

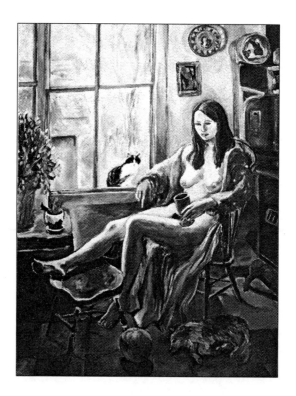

Sunday A.M., **Catherine Ferguson, nd, Oil on canvas.**
Included in the Santa Fe Six Exhibit.

The last choice was problematic. I made a big mistake in not choosing Whitman Johnson. He was fairly new in town. Whitman's landscapes were in the painterly realist style that was currently in vogue in New York. I'd just been to New York and seen a blockbuster ten-gallery show featuring hundreds of artists doing this kind of painting. Now, here it was in our town. I was too wary.

Instead, I asked Paul Wilson. His paintings combined stylistic elements of Fremont Ellis and Tommy Macaione. My motives in choosing him were compromised. His father, Woodrow Wilson, had a gallery similar to Fenn's but much smaller, and with less flashy taste. Paul's work looked all right in the context of his father's gallery. In fact, I found out later that he worked from photos taken by his father. I thought Paul was part of the establishment world and would help bridge the gap for our group. It turned out he wasn't part of their world, or of ours. I got the creepy feeling that, although he painted fruit trees in blossom, he hardly ever came out of a dank, slovenly apartment with the television always on. Paul looked like a cross between Raskolnikov and Ichabod Crane.

The responsibility of putting the Santa Fe Six show together was exhilarating, if upsetting. The artists were nervous and hard to work with, especially as I insisted on final say as to what they exhibited. I was in awe of Fenn, as well as of the assistant assigned to our case, Linda Durham. Linda was as professionally feminine as Fenn was salesmanly macho. She was so vivacious, I felt like a nerd. Luckily, Carol Mothner got along as well with Linda as she did with Forrest.

Our opening was quite an event. Fenn gave three awards: Museum's Choice, Critic's Choice, and People's Choice. First, the Museum curator chose a painting and Forrest Fenn bought it for them.

Left to Right: **Catherine Ferguson, Paul Wilson, Carol Mothner, Louie Ewing, Ralph Leon, Eli Levin. This was the catalog cover for our 1977 exhibit at the Fenn Gallery. We all lived in the same neighborhood. Photo by Rolf Koppel.**

Second, the critics selected their favorite piece, and Fenn gave that artist a one thousand dollar prize. I was no longer writing for the *Reporter.* A younger artist named Wally Loniak had taken the job. The other critic, for the *New Mexican,* was Don Fabricant.

The third award was chosen by ballot. The prize was a silly little statue of a baby by Jinkie Hughes.

The six of us each hung six paintings. The exhibition spread through the left side of the gallery—the handsome, big end room with the fireplace, and the alcove room that includes the wall of palettes.

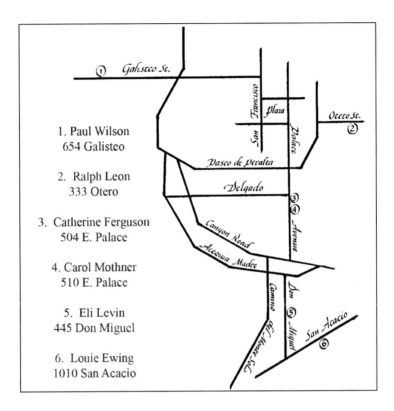

1. Paul Wilson
654 Galisteo

2. Ralph Leon
333 Otero

3. Catherine Ferguson
504 E. Palace

4. Carol Mothner
510 E. Palace

5. Eli Levin
445 Don Miguel

6. Louie Ewing
1010 San Acacio

Map from the Santa Fe Six Catalog.
It's amazing how close we lived to each other.

We had a handsome catalog, though not in color, because this had been at our expense. On the cover was a photo of our group sitting on a log in Fenn's front patio, a pioneer wagon nearby, taken by Rolf Koppel. Inside the catalog each of us had two pages: picture on the right, text on the left. Gene Cluster designed and had it printed. I could have killed him when the press conference started and the catalogs had not arrived. Halfway through, they showed up.

The wine, the hors d'oeuvres, the efficient staff—it was elegant. There was a big crowd, which got pretty happy towards the end. The ballot box for best painting, which many hadn't noticed, had about fifty entries.

As a grand finale, Fenn's publicity director, an old Chicago ad man named John Rivenburgh, stood on the table to announce the winners. I'd been hoping for Linda in a bunny costume.

"Museum Award…," he shouted in his rasping voice as he opened a little envelope, "Carol Mothner."

Carol's painting depicted apple trees in blossom. It was an effusively pretty, Corot-like picture. We all cheered.

"Critics' Award." Again he fumbled with the envelope. "Carol Mothner." This picture was an earlier work, a harlequin in a moody, dark room done in New York in the days when Carol was a waitress at Le Figaro.

More cheers, though from some of us artists, a little forced.

"Popular Award." Again the crowd hushed and tensed as John opened the last envelope. "Catherine … no … Carol Mothner!"

Ducks in the pond at La Cienega, another charming picture much like the apple blossoms.

"Well, thanks for nothing," was my first though. I won't venture to guess the feelings of the other members of the Santa Fe Six.

When we left, Rivenburgh gave me the tally sheets of the popular vote. "Study them, you might learn something." Totaling the votes, I was second, Paul Wilson third, Louie Ewing fourth, Ralph Leon fifth and Catherine Ferguson last.

It was hard for Louie, though he didn't say anything. Louie had always considered himself a people's artist. But it was devastating

for poor Catherine, who had already been in crisis over her work. She pretty much gave up painting.

There were almost no sales. Thank God, Fenn bought one of Louie's. It was the best one, I thought: old-timers sitting in a doorway with hens in the yard.

Even Carol ran into disappointment. Fenn still declined to represent her work. He seemed disenchanted with the whole enterprise. His disdain for the local art world increased. Other galleries weren't impressed by Mothner's day of glory either. If their directors were even aware of our show, let alone Carol's awards, they seemed prejudiced against Fenn and his type of showmanship.

It all went so fast, one glorious weekend.

Many of Carol's paintings sold to her friends and acquaintances. When she was represented in galleries, she engineered more sales than they did. As Carol's prices rose, her paintings got smaller and tighter. She had become a workaholic, compulsive in her habits. It was depressing to see Carol in the corner of their dark living room, hunched over the palette, a crudded up kitchen plate in her lap. She used a student-grade aluminum easel.

She tunneled her way into an obsessive project: to paint bouquets of flowers, Dutch style, even down to the tulips. There were eight paintings, and each individual flower in each bouquet was painted separately. Every day she would bring in a flower from one of several greenhouses and transcribe it into one of the eight compositions. If the flower lasted several days in the refrigerator, it might be used for more than one painting. If it wilted too soon, Carol searched for a replacement just like it.

As the months dragged on, the painted bouquets filled out.

This slow build-up lasted for over a year. Her method would seem to preclude unifying vision, but the paintings maintained a literal-minded integrity, and even a little brilliance.

Carol's tension, always high, kept mounting as she came closer to finishing. She pulled it off. She emerged a more serious artist. She had sacrificed her soft colors, sensual brushwork, atmospheric effects and sense of scale. But the increased sense of "the real" gave this work a new edge.

During this project Carol's marriage fell apart.

Still Life with Radiator, **Carol Mothner, 1979, Oil on panel, 16 in. x 18 in.**
Flower by flower, two and a half years in the making.
Notice that the two top flowers were painted out.
Catherine Ferguson's house is reflected in the window panes.
Carol is reflected in the vase. Photo by Richard Faller.

LANDSCAPE PAINTING
WITH CAROL AND MARJORIE

At the time of our Fenn exhibition, which was in 1977, a few months before the Armory Show, Carol lived on Palace Avenue with her first husband, the writer Robert Mayer. Their apartment was in an old adobe with small windows, thick walls and high ceilings. There was wall-to-wall carpeting, an ugly green shag. It complemented their shaggy dog, Piper.

Robert had been a successful columnist for *Newsday*. Their friends were quick-witted. When they invited me over to join their ritual of watching the Miss America pageant I couldn't keep up with the repartee, which was media oriented.

Divorced from Robert Mayer, single and fortyish, Carol Mothner was intent on being a career artist. Carol's friend from her student days, Marjorie Portnoy, came to Santa Fe on a painting expedition. Marjorie had managed to survive on the fringe of the New York Realist movement, painting bucolic summer landscapes. She was very short and had an enormous bosom. She had sparkling eyes, a small chin, delicate skin and a big wart on her cheek. Her personality was endearingly lively, sometimes childlike.

Carol and Marjorie insisted on finding idyllic scenic spots on our painting outings. There had to be a roadside stopping area, as neither of them felt comfortable away from the car. They wanted to stay close in case any threatening locals came around. They had a big beach umbrella, which Marjorie rigged so that it wouldn't blow over, and smaller umbrellas specially made to attach to their French easels. They sat on folding lawn chairs. The high point of the day was the wonderful food, bought in Santa Fe at Becker's Deli or the Winery.

From Marjorie I picked up a lot of gossip about the second generation painterly realists. There were some technical pointers, too. Marjorie practiced a patchwork approach, tackling each element in the picture separately. This gave a photo-like, super-real aspect to details. Odd, how similar Marjorie's technique was to Carol's in her flower pieces.

Marjorie's boyfriend was Daniel Morper, another New York Realist artist. Daniel also liked to paint the Southwest, especially the Grand Canyon. On another occasion he came out and painted with Carol. Unfortunately for Marjorie, Daniel turned out to be Carol's Mr. Right.

DON FABRICANT

Newly arrived in town, Don Fabricant called, claiming we had a mutual friend in New York, Wendy Gittler. Later Wendy told me that she didn't know him. That was Don's way: conniving, cajoling, wheeling and dealing. He combined servility and aggressiveness. Don had a mobile, lined face rimmed in long unkempt hair, a big nose and beady eyes. These were stereotypical Jewish characteristics that sometimes I found embarrassing. He soon adopted the local bohemian garb: worn blue jeans, cowboy boots, a stained cowboy hat, and an old sports jacket.

Fabricant knew a lot about the art world, intriguing me with stories about the New Realists. Back east he had been on the fringes of that group and painted a few impressive bleak cityscapes. Less to my liking, Don would also gush over Matisse, De Kooning and all that litany of superstars.

Fabricant ran around Santa Fe making connections, then went back east to get his things. He returned with a large rental truck that was crammed full. Don could have opened an art store with the supplies he had appropriated from the small New England college where he had taught. He even brought three disciples, a girl and two guys.

***Self-portrait*, Don Fabricant, 1976.**

They had rented a rundown Victorian house that was hidden behind a bicycle shop on Cerrillos Road. I stopped by as they were moving in. It was an instant college slum dwelling. There were rucksacks everywhere, mattresses on the floor and incense burning. In the kitchen was a round oak table just like the one I'd had as a student, already cluttered with coffee cups, a wine bottle, some joints and Castaneda's *Teachings of Don Juan*.

Fabricant had all the detritus of an overstuffed studio: a human

skull, a cow skull and even a pig skull, antique toy cars, Morandi shaped bottles already dusty. Impressively, he had a great collection of art books of a quality rare in Santa Fe.

Jumbled together with all his art paraphernalia were stacks, heaps and piles of his artworks.

Don and I were lumped together in the local art scene. We were both Jewish, from New York, Realist painters, conversant in art history, both single, neurotic and bohemian. We built our studios at the same time. Both were kiva shaped, with balconies.

We were both in the same group therapy. We clashed with such intensity that the leader had to discontinue the sessions.

Fabricant liked to point out that he had more and better of everything. Each and every item had been an unbelievable deal, a fantastic find. From a truckload of bricks to a woman, he was always in the right place at the right time.

Fabricant once amusingly confided to me that in the Old Country his ancestors had been named Duckshitz.

"That would be bad enough," he added, "but imagine being called 'Donald Duckshitz.'"

Don's parents had died just before he moved to Santa Fe. They left him some money, and he bought a spectacular site on a hill overlooking Seton Village. There was an unfinished, fire damaged structure. Don's studio featured enormous picture windows and wide wood decks. He hired some experienced workers, though he too had his share of flaky help. We even sent them back and forth to each other.

Connected to his studio was a rabbit warren of odd rooms. While none were finished, some were falling apart. Fabricant's house would have inspired Kafka. Who lived there? What was shared and what private? What was usable, what detritus? Each time I visited

there were different inhabitants: his ex-wife, his son, his former girlfriend, his current one, a renter, the renter's sub-tenant. There was no shortage of dogs either, predominantly Afghans and Dobermans.

Whichever section Don lived in, there the clutter was densest. I had to pick my way among flea market furniture piled with incongruous conglomerations that included many pre-Columbian and African artifacts. Most of the kitchen was occupied by an ancient etching press and its accoutrements. Condiments shared a shelf with bottles of nitric acid and the pig skull. There was a plethora of cooking utensils—Don was also a gourmet cook.

Etchings, drawings and paintings were everywhere. There seemed to be no separate painting area. On the old upright piano sheet music and records were chock-a-block with building supplies, and all were coated with adobe dirt and sawdust. Finally, the debris of past parties was everywhere in evidence.

Shifting a stack of art books from the seat of a broken chair, I looked for a level surface to put down the cup of tea that Fabricant had brewed for me. A big dog was sniffing between my legs. Don, not noticing my discomfort, was trying to sell or trade with me everything around us.

Don had terrific girlfriends: young, good looking, bright, artistic and faithful. He watched over them and they helped him with his projects.

Rumors began to circulate that Fabricant had unusual tastes. It excited him if a woman wore a cashmere sweater backwards and a silk scarf. Always with the woman's permission, he would pursue certain fetishistic rituals. He took photographs and sometimes cut them up to make collages, all of which Don kept locked in the pantry along with other accessories.

In our group therapy sessions Don used to assert, "So what's wrong if it's between two consenting adults in the privacy of their own home? My analyst in New York told me, 'Accept yourself, enjoy yourself. The only sick thing is to be ashamed.'"

When his longtime girlfriend Pamela left him she was quite upset. She often came to my studio, regaling me with her Fabricant stories. She built up an elaborate case against him, much of it hard to believe. She even said that she went to the police several times, but admitted that they could find nothing illegal.

In the middle of all this I introduced Pam to a young Israeli, Itamar Levi, a friend of my brother in Jerusalem, who had showed up unexpectedly in Santa Fe. Eleven days later, Pam and Itamar were married. They left for Israel.

ARTIST'S GROUP

Don Fabricant and I were both active in the forming of an artists' protest group. There had been a steady influx of young painters during the early 1970s until there were hundreds. Santa Fe still had only a few serious galleries, including Jamison, Janus, Hill's and Seth's. The Fine Arts Museum had no contemporary exhibitions except its biennials, and the biennial rejected fifteen artists for every one it took. Another problem was that the new artists felt there were too few studio spaces, at least by Soho standards.

We called various public meetings, some at my studio and some at Fabricant's. Others were held at Graphics House and at the studios of Forrest Moses, Ford Ruthling and Sam Scott. For bigger, general meetings we used Hill's Gallery, and a few times we met at the Upstairs Gallery of the Museum.

The meetings took a variety of forms: debates, guest artists, bring-your-slides, and even bring-your-paintings. One of our events was Fritz Scholder's lecture on the economics of selling a lithograph. That was a revelation to idealistic artists.

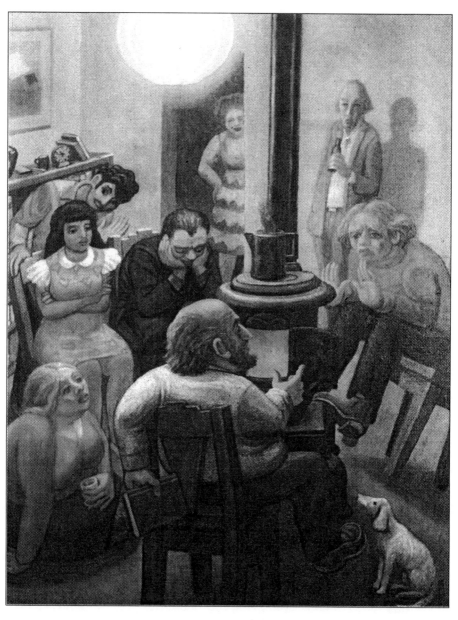

Artist's Group, Eli Levin, 1985, Oil, 40 in. x 30 in. Frank Croft Collection.

Fabricant and I helped write a petition to the museum. We asked for ten theme exhibitions featuring works by local artists. The director, Don Strel, met with our whole pack of artists in the Museum lobby. We spoke out and he was clearly on the defensive. Within the next couple of years, Strel did mount five of the suggested shows. I remember four: color field painting, landscapes, visionary art and graphics.

After months of meeting in enemy territory, our protest group rented a rundown adobe building on the corner of Old Santa Fe Trail and Arroyo Tenorio. It became our artists' club, vaguely similar to the famous New York Scene Club of the 1950s. The abstractionist contingent dominated. In residence was Jerry Kirby, a coffee house habitué. He was crass, but enthusiastic. He talked like a disk jockey, loud and entertaining. He'd done everything, and now wanted to sculpt.

We had weekly meetings, and even a few in-house exhibits. A few artists (mostly Ettenberg) used the main room as a studio during the day. There were always a few of Brad Smith's bronzes, totemic-industrial, scattered around. We drank cheap wine and argued about art. These good times lasted for a year or so, with much mixing of old and new artists.

New galleries materialized, and more chances to exhibit turned up. For instance, Bob Tomlinson, a young man from Albuquerque, opened an unlikely Basement Gallery in an obscure location on Montezuma Street. Tomlinson took into his stable all our wannabe abstract expressionists as well as some slightly more figurative expressionists.

Santa Fe was becoming aware of itself as an art center.

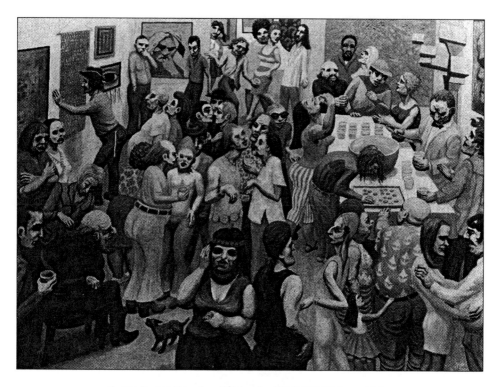

Santa Fe Art Opening, Eli Levin, 1979, Oil, 30 in. x 40 in.
Myself, lower left; Fabricant, upper left, rope in back pocket.
This painting was destroyed in a gallery fire.

THE ART FESTIVAL

Rumors began to circulate that some Chamber of Commerce people were going to drum up an art festival. The woman in charge, Sara Sheldon, agreed to come to my studio and tell our group about the plan. Forty artists showed up. The festival was still in the formulation stage. Sheldon told us that originally, Forrest Fenn had wanted to make Santa Fe a showplace for Western art. Other local powers resented Fenn's cavalier approach so Fenn backed out, saying, "Do it yourselves." The basic impetus that they all agreed on was to prolong the tourist season by introducing this festival in October.

Part of our group wanted to be in the festival. We wanted good art (including our own) to be featured. Others, with Gene Newmann taking the most extreme position, didn't want anything to do with Sara Sheldon. No compromise. The Chamber of Commerce cared only about money and could have no empathy for art.

Sara Sheldon was a Type A businesswoman who had been married to a cowboy sculptor. Confronted with our scrofulous group in my dank mud studio, she must have felt she was visiting the lower depths.

As the festival plans firmed up, it became clear that Sheldon and her entourage wanted "name" artists. They would include only a few of the best known locals, and then invite famous artists from all over the country. They tried to make a list of nationally known artists, but none of them knew anything about art. I could name ten times as many American artists as all of them put together. "I wonder if that guy in Dallas who painted clowns is still alive?" said the owner of the art supply store. Sam Scott and I went to their meetings as unofficial liaisons, but when our group asked to be represented on their board, their committees, and so on, they turned us down.

We decided to have an exhibition of our own. There were several possible places. I enthusiastically favored the suggestion of the Santa Fe Armory on Old Pecos Trail. I had recently read a book about the original 1913 Armory Show in New York. There were several parallels that gave our show a certain piquancy. The Santa Fe Armory was a kind of empty shell that was being used for experimental theater, media exploration and video. It had a nonprofit tax umbrella called Rising Sun. This made it possible for us to raise money.

Our seemingly ragtag group turned out to have connections all over town. Conversely, Sheldon and the festival backers, with their pretensions, were oblivious to the workings of the growing art community.

With Steve Catron's help I put together an art auction. Though now commonplace, this was an untried experiment back then in Santa Fe. We used the new Casablanca nightclub in La Fonda, whose sympathetic owners were a would-be writer and his wife, who painted a bit. The sunken dance floor ran down the middle, with tables along either side and the bandstand at the far end. Steve and I rounded up about fifty works of art, mostly culled from our group.

There was a surprisingly high level of work, rather than the prints, posters and studio scrapings that have since become the staple of charity auctions.

The morning of the auction, Steve and I put the art works on tables and easels down the middle of the room. The press had already come through with sympathetic articles. Many people drifted in to check our wares. The owners were happy to sell drinks to new customers, especially as the evening approached and things picked up. Linda Durham, who had just opened her gallery, was our flashy auctioneer. Gene Newmann assisted her, giving the proceedings an authoritative tone with his deep rabbinical voice and knowledge of the art.

We still thought of ourselves as outsiders, and were relieved to see the room fill up with people. We knew that the fifty artists would show up, but this was beyond our expectations; the place was crammed. There was terrific excitement and anticipation.

Most of us were not exactly best-sellers. As Steve and I brought each art work up to the spotlighted easel, piece after piece sold. There was a growing euphoria. All fifty items were purchased. With no overhead, we made ten thousand dollars. In many cases the sales prices were higher than the artist would have asked. How simple life was then! Now some of the same artists ask more than ten thousand dollars for a single painting.

Our Armory Show developed momentum. We had meetings every week at the home of Dick Thibodeau, a picture framer.

Finding a fair jury system was another big struggle. I prevailed with a concept I had borrowed from a New York exhibit years earlier called Art U.S.A. Twenty-five of our most established artists each picked four more artists. All one hundred then exhibited three works

each. There was much acrimony about who would be in the honor group. I politicked heavily, pushing for a broad spectrum that included several old timers. This jury system, which seemed fair to me, turned out to have one big fault. The sponsoring artists ushered in spouses and lovers regardless of their abilities, and artists often submitted their own worst work.

Our rebel group proved itself when confronted with the stygian task of converting the gloomy, hangar-like interior of the Armory. Many of our artists made a living as construction workers, and builder friends who weren't even artists volunteered out of good will. It took a great effort, but we dismantled the stage and bleachers, stacking them at the far end of the room. This gave us enormous space. Subsequent art exhibits at the Armory never made this effort, but just used the front rooms. Hanging the panels from the extremely high ceiling and figuring out a lighting system were also great challenges. My only involvement with this beehive of a project was to paint a decorative stripe along the wall.

ARMORY VS. FESTIVAL

S am Scott and I went back and forth between Armory and Festival meetings. One of our few positive achievements was to get the Festival group to include Armory information with their own mailers, which went out to an enormous list of people.

The Festival group resented the Armory show, justifiably afraid that we would undermine their efforts. For our part, we were confounded by their lack of understanding of art, and amused by the muddled complexity of their plans. We put together our blockbuster for ten thousand dollars while their smaller exhibit in the balcony of La Fonda cost them around eighty thousand dollars.

The Festival was plagued with shipping problems because of their "nationally known" artists. When the crates finally arrived at the eleventh hour and were opened, the organizers discovered that the more important the artist, the less significant was the proffered piece. Among their hodge-podge of "names," the only artists I remember were Morris Graves and Charles White. Both were good artists, though out of fashion, and both sent lesser graphic works. The clown artist came through.

Sheldon thought she had made a coup by getting a promise for a poster image from Clark Hulings, the darling of the academic Western art circuit. He specialized in Mexican markets in raking sunlight. But Sara couldn't dissuade him from giving them a banal and touristy image of a burro.

The Armory group had a competition for our poster. I was one of the judges. Steve Catron had not submitted anything and was out of town. Before the judging, I called his mother. With Mrs. Catron's complicity I went through his studio. She looked on anxiously while I ferreted out several of his manic drawings full of local characters. They were intense images, but also subtle and delicate. It was impossible to find a simple "graphic" one. Nevertheless, Catron won. We used a fine screen reproduction to get as much resolution as we could. Unfortunately, the layout artist used a black border, overwhelming the image. It wasn't exactly eye-catching, but it wasn't a donkey.

THE FESTIVAL CAMP

Sara Sheldon was around forty. She was sinewy, and abrupt in her movements. She had big, expressive eyes; her voice was gravelly with a slight Midwestern accent. She worked hard, though chaotically, reveling in her own Byzantine enterprise. She was a hell of a woman to work with. Sara was lucky that her assistant, Linda Monacelli, was ever attentive and capable. A nice-looking, calm young woman, Linda tried to piece things together in the eddy of Sheldon's histrionics.

SARA SHELDON'S TEAM

Wally Sargent, the bearded, bustling and boyish realtor, had an art collection that included most of the Santa Fe art colony founders.

Pony Ault was a waspy society do-gooder with many projects about town. Her son, home from college for the summer, proved invaluable to the Festival. He supervised the uncrating, hanging, recrating and shipping of the art.

Concha Ortiz y Pino de Kleven was another society woman, the other side of the coin from Pony Ault. She might have stepped out of Goya's Caprichos.

Doctor Kosicki hosted several Festival meetings in his outsize living room, adjoining an indoor pool. His extensive art collection, heavy into Southwest arts and crafts, bordered on kitsch. There were some good pieces buried in the clutter. Hanging in the kitchen was a superb Haddock, done in Taos in the early 1930s. I asked Dr. Kosicki about it. He'd bought several small Arthur Haddock canvasses from Bernie and Bill at Collector's Corner. This was a revelation—the missing paintings! When Haddock was in the hospital with cancer, Arthur sold his house to defray expenses. Bernie and Bill, his dealers, helped him

pack up his studio. Haddock recovered and set up his studio again in the small guest room of his retirement apartment, then realized the works were missing. By then, the Collector's Corner had declared bankruptcy and Bernie and Bill had moved to Texas.

After talking to Kosicki, I passed the information on to Arthur. He was too old and introverted to do anything about it. Several years later, after he died, his widow and Ernesto Mayans, his art dealer, went to talk to Kosicki and retrieved several paintings, including the one I had seen.

Two men were paying court to Sara Sheldon. The first looked like a college football player gone soft. He later was all over town promoting Santa Fe Natural Tobacco cigarettes. The other was a birdlike Taos artist. He had a pained, middle European face and something wrong with his hands; he always wore black gloves. He dressed in black, too, and drove a red convertible. His miniature paintings were comic tableaux of priests and nuns, several of which were in Dr. Kosicki's collection. Recently, he had changed to doing big abstract assemblages.

The Festival's biggest mistake had been to alienate Fenn and the Western artists. Half a dozen of the most prestigious live in or near Santa Fe. They have long waiting lists of purchasers, and if they show at all, it's in the prestige exhibits in Texas, Arizona and Colorado. Fenn had wanted to feature these very artists in his initial conception of the Festival. With Hulings as a starter, they might have had Hurley, Loughheed, McGrew, Steinke, Lowell and Daughters.

THE ARMORY CAMP

S am Scott was big, warm and hearty, like an ex-jock. After bear hugs and backslaps, Sam would pontificate on his art and career. His rap combined the old Abstract Expressionist cant with the new "I'm O.K., you're O.K." slang.

Dick Thibodeau was middle-aged, small, pinched, careful, but open-eyed and concerned. His opinions were considered and businesslike, though often overlooked. He was a good host.

Don Fabricant was usually present. He reveled in art politics. His ideas were good, though he could be hotheaded and aggressive.

Steve Catron and Gene Newmann took purist and separatist positions. Gene's attitude was proud and passive. Steve's was reactive and sometimes hysterical.

Frank Ettenberg had some of the weightiness of Sam Scott, but Frank was softer and his opinions were almost as quirky as Catron's.

Those were the steady participants. Other artists came and went, helping at various stages.

Gene Cluster donated his calligraphy and graphic design for our early publicity. In the later stages of the Armory preparations, two women recently arrived from New York, Michelle Zackheim and

Barbara Gluck, took over our publicity. They seemed to know all about art and promotion. Barbara moved into the large house on Garcia Street that had once been John Sloan's. She and Michelle had the idea of taking a group photo of our whole Armory group of one hundred and twelve people. Seventy-two showed up at Canyon Road Park on the designated morning. We bunched together on a knoll while Barbara climbed a ladder with her camera.

At that moment I sensed our power, as on the night of the auction. We were an art movement! We made a poster of the photo. I still have it, hanging in my bathroom. Where have so many of those artists gone?

We also used the photo in the entrance way to the Armory, blown up large enough to cover the whole wall.

MY CONTRIBUTIONS TO THE ARMORY SHOW

As the Armory Show momentum built up, I withdrew somewhat. I was concerned in the planning stages that it be an inclusive exhibition with old-timers, outsiders and realists, and not just the cabal of new abstract artists.

The "avant-garde" phalange was spearheaded by Gene Newmann, Sam Scott and Frank Ettenberg. Their styles were close enough to be a movement, though of course they denied it. Although it was generic modernism by New York standards, it was serious art for Santa Fe. Around their nucleus a "refuses" show could have been developed. They would have been all too happy if I had not been there promoting realism and traditional Santa Fe art.

Realists were in no-man's land between the abstract artists and the Western artists. The abstractionists made our work look too prosaic, and the flashy academic artists made it look amateurish.

The old-time Santa Fe artists had problems, too. Their careers had floundered during the war and after, when the art colony came apart. Forgotten, they reminisced about the good old days while the new art scene developed without them. Some were bitter, some indifferent, some oblivious, but few tried to keep in touch with new art developments.

I'd made sure that several old artists were jurors and because of that, most of them were included in the show. As a juror myself, I chose three of the oldest, all in their eighties: Arthur Haddock, Eugenie Shonnard and Barbara Latham.

One of Shonnard's entries was a bronze relief of Igor Stravinsky, done from life. The Lathams were Taos landscapes, done in egg tempera, marvelous paintings in a technique lost today. Haddock, who had reclusively piled up a lifetime of strong work, was for me the most exciting discovery. Going to their studios and looking through their work was the most pleasurable task I had during the Armory Show.

Some other old artists sent in awful pictures, but then, so did some young artists. There were jurors who practiced nepotism, or who just had bad taste.

Because it was the Armory Show, I came up with the clever idea of featuring Andrew Dasburg, the only artist still alive who had exhibited in the 1913 Armory Show. He was living in Taos. His son, who lived right around the corner from me, turned out to be most helpful. He lent us art, clippings, mementos. We put together a special Dasburg wall in the entrance way of the Armory. I wrote a lot of the statements and press releases, including one that compared our show to the 1913 prototype.

As the opening day approached, our gang became a bit giddy. Someone donated an old car for us to use in the Fiesta Hysterical parade. A "committee" transformed it into a rolling art piece. On the rear-view mirror I painted an imaginary reflection of back seat sex. Oliver Ortiz cut a hole in the roof and built a turret, made of adobe, with little vigas. The outside of the car was a rainbow of patterns and graffiti.

Group Portrait of Local Artists in the Santa Fe Armory Show, 1977,
Barbara Gluck ©. Taken at the Canyon Road Park.
Fabricant couldn't be there so he gave us a cutout photo of his head.
Poster/photograph available, visit www.barbaragluck.com.

THE SANTA FE ARMORY SHOW

1. Thomas Macaione	29. Walter Cooper	57 Eugene Newman	Barbara Gluck
2. Fritz Scholder	30. Forest Moses	58. Alba Newman	Arthur Haddock
3. Dennis Larkins	31. Helen Beck	59. Jorge Fick	John Hogan
4. Holly Cary	32. Megan Hill	60. Sally Haozous	Ernie Knee
5. Jim Wood	33. Marie Marsellis	61. Susan Case	Rolf Koppel
6. Douglas Johnson	34. Whitman Johnson	62. Gretchen Cohen	Karen Lee
7. Jilly Janis	35. Paul Wilson	63. Meridel Rubenstein	Ralph Leon
8. Sam Scott	36. Mary Sundstrom	64. Carol Mothner	Spencer Lyons
9. Tom Hicks	37. Julie Sullivan	65. Eliana Flach	Anne McLaughlin
10. Tom Dryce	38. Judy Greeny	66. Lynn Lown	Jack Miller
11. Ed Haddaway	39. Ann Moul	67. Chris Seubert	Linda Miner
12. Bill Tate	40. Oliver Ortiz	68. Winston Culpepper	David Outhwaite
13. Brad Smith	41. Eli Levin	69. Ray Belcher	Carrie Peterson
14. David McGarry	42. Dona Quasthoff	70. Bob Haozous	Paige Pinnell
15. Peter Rogers	43. Janet Lippincott	72. Steve Catron	Tony Price
16. Jim Webster	44. Sibyl Saam	**Artists Not Pictured**	Jean Promutico
17. Charles Ramsberg	45. Sheila Satkowski	Charles Barrows	Ed Ranney
18. Woody Gwynn	46. Boyd Nicholi	Delmar Boni	Eric Renner
19. Joel Parrill	47. John Fincher	Andy Burns	Dolona Roberts
20. John Kindred	48. Dana Newman	Paul Caponigro	Paul Sarkisian
21. Mary Sarns	49. Hulda Sellingsloh	Bill Clift	Irene Schio
22. Agnes Sims	50. Aliza Mandel	Clarabelle Cone	Elmer Schooley
23. John Massee	51. Louis Ewing	John Connell	Eugenie Shonnar
24. Mary Peck	52. Dick Thibodeau	Terry Conrad	Michael Smith
25. David Howard	53. Jerry West	Doris Cross	Charlie Southard
26. Frank Ettenberg	54. Don Fabricant	Eleanor DeGhize	Art Thomas
27. Ginny Walden	55. Jim Hill	Laura Gilpin	Alex Traube
28. Barbara Latham	56. Catherine Ferguson	Elaine Ginsberg	Brooks Willis

ARMORY FOR THE ARTS ● OLD PECOS TRAIL ● SANTA FE, N.M. ● OCTOBER 1-15

Photograph © by Barbara Gluck / Poster Courtesy: Photo Supply and the Camera Shop

THE BIG EVENT

The opening night in October of 1977 was a euphoric whirl. Every artist and art enthusiast in town was there. We moaned and groaned at various embarrassing entries, but over the week our attendance figures were terrific and the press was full of praise. But then, they had favored us outrageously from the beginning.

Looking back, I'd say the actual exhibition was important as a catalyst and a survey, regardless of quality. About one fourth of the artworks were really good. It was an indicative showing, giving a fair estimate of what New Mexico had to offer in contemporary art. That hadn't been done since the days of the W.P.A. and the alcove shows in the Museum.

I learned that though I thought of myself as a loner, I proved to be a persuasive organizer. Surprising, too, was the concerted group effort, which disproved many prejudices about artists.

To many of us who were there, it was the high point of the Santa Fe art scene. So much that exists now grew out of our exhibition. And yet, perhaps because artists come and go so quickly, the Armory Show is almost forgotten.

EXHIBITORS, JURORS INCLUDED, FOR THE ARMORY SHOW

Personal Selections by Jurors

Doris Cross:	Jean Promutico	Carol Mothner:	Catherine Ferguson
	Charlie Ramsburg		Ralph Leon
	Ann Moul		Iren Schio
	Michele Graham		Gretchen Cohen
Frank Ettenberg:	Steve Catron	Carrie Peterson:	*Meagan Lloyd Hill
	Barbara Gluck		*Dana Newmann
	Ginny Walden		*Mary Sundstrom
	Jilly Scott		Jim Webster
Louie Ewing:	Brooks Willis	Paul Sarkisian:	Cris Seubert
	Tom Dryce		David Outhwaite
	Charles Barrows		Terry Conrad
	Dolona Roberts		
Don Fabricant:	Andy Burns	Fritz Scholder:	Doug Johnson
	Clarabelle Cone		Peter Rogers
	Whitman Johnson		Elmer Schooley
	*Marie Marsellis		Bill Tate
Bob Haozous:	Sally Haozous	Agnes Sims:	George Fick
	Delmar Boni		Sibyl Saam
	Dick Thibodeau		Walter Cooper
	Spencer Lyons		Dona Quasthoff
Tom Hicks:	Jim Hill	Sam Scott:	Gene Newmann
	Janet Lippincott		Julie Sullivan
	Joel Parrill		John Connell
	John Massee		Dennis Larkins
Eli Levin:	Eleanor de Ghize	Brad Smith:	Tony Price
	Eugenie Shonnard		Dave McGarry
	Arthur Haddock		Jack Miller
	Barbara Latham		Ed Haddaway
Tommy Macaione.	Judy Greeney	Jerry West:	John Kindred
	Susan Case		John Hogan
	Hulda Sellingsloh		Charlie Southard
	Paul Wilson		*Oliver Ortiz
Forrest Moses:	*Jim Wood		
	John Fincher		
	Helen Beck	*Selected from submissions on July 16	
	Woody Gwyn		

Photographers Invited Jointly by Paige Pinnell and Ray Belcher

Paul Caponigro	Ernie Knee	Boyd Nicholl	Eric Renner
Bill Clift	Rolf Koppel	Mary Peck	Meridel Rubenstein
Laura Gilpin	Lynn Lown	Ed Ranney	Sheila Satkowski
*David Howard			Alex Traube

Exhibitors Selected on July 16 by Open Jury

Holly Cary	Elaine Ginsberg	Aliza Mandel	Michael Smith
Winston Culpepper	Karen Lee	Linda Miner	Art Thomas
Eliana Flach	Anne McLaughlin	Mary Sams	

One hundred and ten artists, three pictures each.

SAM SCOTT'S STUDIO

At the time I was building my studio, Don Fabricant and Sam Scott were also building theirs. They had greater resources than I had. Sam had wangled a government small business loan during that time of social services and welfare. He put in a brick floor, a Heatilator fireplace, skylights, painting racks and a sink—none of which I had. He had a nice piece of land with a separate little house to live in. There was also an odd structure that he called a sauna. It was like a big oven with a little doorway that one climbed through.

During the period that we worked together in the Armory Show, I became familiar with his place and grew less envious. The brick floor was laid crookedly, and the bricks themselves were raw, rough and too orange. The fireplace was placed too far from the painting area. The skylights were corrugated plastic over rectangular holes in the roof. This caused the sunlight to move around the studio, which made it difficult to paint by, even abstractly. Due to Sam's predilection for painting big and fast, the racks took up half the space. The sink, badly fitted, had only cold water. Its long counter was heaped with all the filthy junk that is the usual paraphernalia of contemporary art.

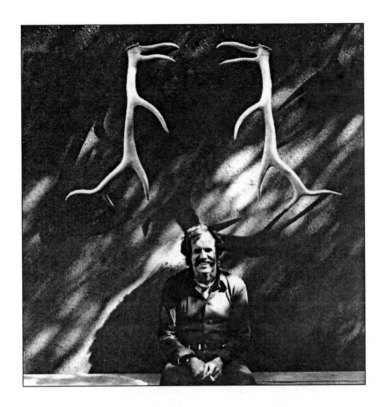

Sam Scott, 1975. Photo by Karl Kernberger.

Sam's house hugged the uneven ground like a peasant's hut. It was dark and damp inside, with a very low ceiling. Inside were sagging shelves and dirty dishes. Still, Sam's place had a poetic ambiance. Parking at the top of a very steep, dead-end street, one entered his property on a radical descent, dodging under the branches of crooked pine trees. It was a very private spot, dark and hushed.

I was most familiar with the studio, having posed for my portrait there. Sam installed a big pot-belly stove in the corner by his

painting wall, a grid of two-by-fours with pegs protruding at intervals. Big canvasses could be hung anywhere on this framework. Newmann and Ettenberg had the same setup. Sam also had a big, awkward homemade floor easel that he said had belonged to Fechin. He used it to paint my portrait. The easel was terribly clumsy, especially on that uneven floor. Cigarette butts were thick in the ruts between the bricks. I thought his portrait of me was terrible, and I did one of him, sitting in my studio, which I also hated.

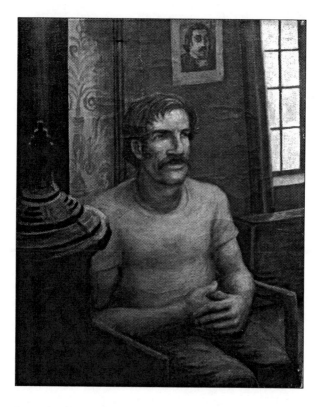

Portrait of Sam Scott, Eli Levin, 1973, Oil on canvas, 30 in. x 24 in. The canvas used for this painting was the back of an awning. Sam suggested the Gauguin self-portrait in the background. Photo by Cheryl Anne Lorance.

Scott's roof leaked worse than mine did. One winter when Sam was out of town he lent his studio to Gene Newmann. Gene found it too hard to keep warm and went somewhere else, leaving some paintings behind. Water dripped on them, then froze and melted alternately until the canvasses warped and cracked.

Guardian Singing to a Water Gourd, **Sam Scott, 1976,
Oil on canvas, 36 in. x 48 in.**

Sam had unusual artifacts. Suspended from the vigas was a small canoe, and on the wall hung a big fish jaw. Also on the wall was a framed photo of Sam and a couple of other white people, surrounded by black jungle people. Exotic objects and pictures gave the place

a Jungian aura. A wood crateful of beat-up books hinted at a broad taste: some existentialism, some classics. Had Sam read any of them? I found a beautiful old edition of Trilby with a torn cover. I borrowed it (and still have it).

In Sam's painting racks was a collection of his best works. Scott's Scotts. He said he was saving them to be his son's inheritance. Later he came upon hard times and had to sell some of them.

Some years after the Armory Show, he added a room to the little house. It was handsome, spacious and well built, moving up from hippie to solar. After his marriage broke up, he rented out the house. He built a tiny living area above his studio, enclosing an awkward space over the painting racks. The entrance was from the outside, reached by a wood staircase.

I gave Sam's portrait of me, along with another painting by him, to a fundraising sale for the Amory for the Arts. The Armory was by then on a downhill course. I didn't hang around to see if anyone bought Sam's paintings. Some months later I was in an office of the Fine Arts Museum and there on the wall was Sam's other painting. Susan Streeper saw me looking at it and told me how, luckily, she had found it for only a few dollars and snapped it up for the Museum collection.

FRANK ETTENBERG

Having mentioned Newmann's water-damaged paintings brings to mind a similar debacle that happened to me. I had a little gallery on lower Canyon Road called Graphics House. I shared it with John Fisher, who lived in the back and ran the place, using the floor space for his antique furniture.

I was going to give Frank Ettenberg a show. He and I selected about thirty works on paper, mostly colored pencil drawings and a few done in ink. I took the pictures to my house, as I had agreed to mat them for him in trade. They were in a portfolio, which I put on a chair in my workroom/bedroom. At that time I was building a second floor over that room and had removed the *canales*.

In the middle of the night my girlfriend Janet and I were awakened by a storm and the sound of splashing water. She turned on the light. We were mesmerized by the sight of a stream of water pouring into the room, directly into Frank's portfolio. The chair stood in the middle of a small lake. We whipped the portfolio away, but when we opened it the drawings were a soggy mess.

Frank Ettenberg in his Lensic Building loft, c. 1981.
Photo by Marilyn Foss.

Neither of us got any more sleep that night. We peeled each drawing off, then frantically dried it with cloth towels, paper towels, even toilet paper. The ink drawings had begun to blur and run. The colored ones wrinkled as they dried. We threw the colored ones in the bathtub and filled it with water. This gave us time to finish blotting the ink drawings. I had blotters that I used for etchings, and glass for framing. We carefully layered each piece between blotters and glass.

By the time we called Frank in the morning, things were under control. I fell all over myself apologizing. He didn't quite forgive me. On several of the ink pieces there was a slight blurring. It seemed to

me that his multitudinous scribbles and squiggles had even gained something, a more harmonious luster. I paid him for four of the most damaged. Frank expected me to destroy them, but over the years I sold or traded them all.

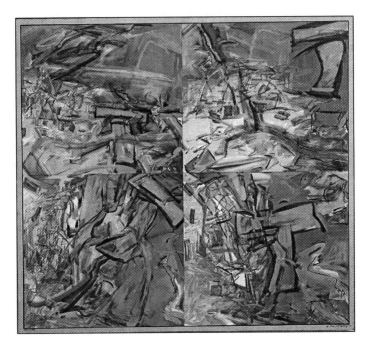

Green Orbit, **Frank Ettenberg, 1974, Oil on board, 32 in. x 40 in.**

Ettenberg became compulsively professional. He built painting racks with doors, all wrapped in plastic. Each picture in its slot had a piece of acid-free tissue paper, cut to size and taped over the picture. He priced his works by the square inch. On his studio walls were several charts with gradations of paint viscosity, color intensity and so on.

By then Frank had the most Soho-like studio in Santa Fe. It was a gigantic loft, an anomaly in a town that characterized its artists as "nuts in mud huts." The loft was downtown over the Lensic Theatre. It must have seemed to the landlord to be useless space because of the cramped stairs and twisted corridors that led to it. His first lease was for one hundred dollars a month, and this even included a kitchen and bathroom. The industrial, generic space was perfectly suited to Frank's big paintings.

Ettenberg did a whole series of paintings on the theme "New York—New Mexico." He would explain, "The difference between my work and the New York school is that, while my brush strokes look spontaneous, they are actually carefully contrived."

GENE NEWMANN

When I first knew Gene Newmann his studio was the garage that came with his simple, lower middle class apartment on Buena Vista. His next studio was in the Garfield Apartments, a slum tenement. This tall, Edwardian structure, stranded in the barrio, had degenerated into a rabbit warren of welfare cases and druggies. Gene loved it. Since then the building had been gentrified, renamed the University Building and filled with lawyers and accountants.

Newmann then moved to a grand old adobe hacienda on upper Cerro Gordo Road. It had a backyard with fruit trees that sloped gently down to the river. The thick-walled house had many rooms. The living room was enormous and had high ceilings. The kitchen, too, was oversized, homey, old-fashioned. Gene's studio was a stone building in the front yard, which had perhaps been a gardener's shed. It was dark and cold inside, and not too large, but had a somber aura that fit well with Gene's painting at the time.

**Eugene Newmann drawing on a lithographic stone at Hand Graphics
Studio, c. 1977. Photo by Julie Sullivan.**

This surprising period of gentility in the Newmann's lifestyle was
due to a hidden talent of Gene's that none of us would have expected. He
had begun trading with Indians at just the right time, when silver and
turquoise became a national fad. Newmann had grown up in South
America and inherited his hidden talent from a family of traders, just
as he inherited his wonderful, deep voice from generations of rabbis.
With little visible effort, disappearing occasionally for a few days, Gene
dealt in baskets from Mexico, turquoise from Hungary and pawn
jewelry from Navajoland. Meanwhile, he continued to paint. When he
mentioned his commerce at all, he off-handedly credited an absurdly
inflated market for Indian goods.

***First Variation on a Theme by Vermeer,* Eugene Newmann, 1979,**
Oil on canvas, 40 in. x 30 in.
Collection of Martha and Doug Keats.

A couple of years later, Gene said the boom was over. He left the hacienda and came back down to the near poverty level. The studio he had for several years after that was in a run down warehouse by the railroad tracks. It wasn't really his, but belonged to another artist who rarely painted. This studio was eventually sacrificed to gentrification when the warehouse became an artsy mall called Sanbusco.

COMPARING THE STYLES OF ETTENBERG, SCOTT AND NEWMANN

Frank Ettenberg achieved a luscious, painterly surface, a glib, Hans Hofmannesque "push-me pull-you." The results were blurred, glowing, cosmic. It was abstract expressionism transmogrified into corporation art. Yet and still, as Ron Adams would say, it was too sophisticated, too avant-garde for Santa Fe. Ettenberg had a hard time. His big, healthy, boyish eagerness was undermined by some inertia, something soft and whining. One year I saw the poor guy driving a cab. Another year he was off to India, in thrall of some guru. Later, the day before his show opened, he had a heart attack.

Sam Scott had a more sustained charisma in art circles. Beneath the glad-handing jock surface was the dumb, primitive seeker. Sam's paintings, terrible mish-mashes of cheap, bright oil paint, were a cathartic relief. Looking at his paintings, I was always reminded of that badly built sink counter in his studio, overflowing with heaps of student-grade paint tubes squeezed into grotesque shapes, leaking at the seams with their tops missing. Sam would lovingly bring out his latest canvasses and elaborately hang them on the rack, just so, one at a time. He would stand back and admire his own work. Sometimes,

with deep concern, he would run up with a spray can of retouch varnish to hit a dull area. How could anyone not feel empathy?

Gene Newmann was the most substantial painter of the three. His style was closer to Ettenberg's than to Scott's, but he started with a more specific reference than Frank did. There was almost a content. He submitted his "image" to an ordeal, a reckoning, a purification. The rationale behind this process was beyond my comprehension, but it is something like what Giacometti went through painting the Portrait of James Lord. The painting went through layers of mutations, and each stage could have been a finished portrait, according to Lord's memoir. Supposedly, the process is as important as the result. Some of Newmann's bygone stages were more eloquent than the often turgid and murky final take. Even when Newmann missed, his hard-won resolutions made Scott's spontaneity seem self-indulgent and Ettenberg's calculations too surfacy.

This was how I differentiated them in my mind. Still, to me they were all throwbacks to the aesthetics of New York in the 1950s.

FORREST MOSES

F orrest and I were slightly acquainted, sketching at the weekly model session run by Bob Ewing at the Museum. Just weeks after Forrest came to town he seemed to know all the right people and was even included in a Museum show. He was a figurative painter, skilled and knowledgeable, a welcome addition to Santa Fe. He was tall and pleasant looking, though a trifle aloof.

When the Armory Show was just starting to get off the ground, we had an open meeting at Forrest's house. His place was impressive, large and tasteful. The meeting turned out to be raucous. Forrest, already anxious, was further upset by a loud, obnoxious Phil Wilburn. Moses did not take part in subsequent Armory activities.

I'd been to visit Forrest before. He had just bought his property but had not yet remodeled the house or added the studio. He had a wonderful garden full of flowers. He invited me to come there to paint. I did two elaborate watercolors that took several days. In one I included his orange cat, half hidden among the flower stalks. While I was there, Forrest showed me his framing setup, in a garden shed. He'd worked out a framing system that was inexpensive and elegant: double stripping, the inside one set back and painted black.

Forrest Moses in his studio, c. 1975.

Forrest thought my watercolors would be more impressive if I used wide mats. I put the two new watercolors in huge pastel mats, at least eight inches all around. I was pleased with the effect but later realized it was pretentious.

Still Waters, Forrest Moses, 1975, Oil on canvas, 42 in. x 60 in.

SEYMOUR TUBIS

Seymour Tubis, a professorial artist, never fit into the Santa Fe scene. He had had all the "right" training, including Hayters Atelier 17 in Paris. The most impressive thing about Seymour was his resumé. He stayed here for years without making his marks and finally, embittered, moved away. A middle-aged, fussy man, he had a nagging kind of insistence. But his self-importance didn't project; Tubis was cultured and sensitive, but boring. I was particularly exasperated by his blind reverence for modern art, the predictable hierarchy of twentieth century genius with Picasso at the top.

Tubis' art was a smorgasbord of semi-abstract styles. He even included natural forms, such as leaves and feathers collaged or printed onto his images. His surrealism was watered down to the point that it produced a lulling effect rather than a jolt of recognition. Seymour used almost every medium. His graphics were his most sustained efforts. The variety was staggering. Each print boasted a different blend of techniques. Seymour was the graphics teacher at the Institute of American Indian Arts.

Seymour Tubis.

I first came across Tubis' work at Jamison Galleries. Margaret Jamison specialized in Western art, but she was nice enough to let some of us local artists hang a few things in the dark corners. Carol Mothner and I would usually have something up. At least our work was figurative. Imagine my surprise when Margaret Jamison hung a whole downstairs gallery with Seymour's prints. Nobody in Santa Fe

even knew what an intaglio print was. My favorite was of a dustpan that Tubis had inked and run through the press.

Seymour Tubis' prize-winning etching. This etching, entitled *The Old Musician*, and dating from Tubis' synthetic cubist period, has been among his most successful works. It won several national prizes and was bought for the permanent collection of the Metropolitan Museum of Art in New York City. Published in *The New Mexican*.

INDIANS FOREVER

At the Indian school the students were undergoing a kind of consciousness-raising. Fritz Scholder, who in 1963 joined the staff as painting instructor, galvanized student awareness into an art movement. The students knew Indian motifs and were very self-conscious about acculturation. Fritz Scholder brought them the stylistic formulas of pop art and California Expressionism. The result was an explosion of expression.

It must have been painful for Seymour Tubis to stand by and watch, an outmoded aesthete whose technical expertise was so inimical to the movement. His perfectly set up graphics workshop was uninspiring to these fervid youngsters who didn't know and couldn't have cared less that graphic art was once *the* socially conscious medium.

One crowded night at Claude's Bar I found myself sitting with a couple of taciturn young Indians who looked like auto mechanics. The heavier one said to me, "I'm an artist; I'm the best artist in Santa Fe."

This did not seem possible. "Are you better than Scholder?" I asked. (A private joke: a professor at St. John's College had once canceled my proposed exhibition with a similar comment.)

"Hell, I taught him everything he knows. His paintings were shit until he started stealing my ideas."

"Well, what's your name? I guess I'd better try to remember it."

"T.C. Cannon."

I had never heard of him. I thought it was funny then. And now that he's famous, and dead, I still think it's funny, though there was an element of truth in what he said.

Though T.C. was Fritz's student, one of Cannon's earliest paintings set the standard for the new Indian art. Titled "Let Them Eat Grass," a quote from Custer, the painting was powerful: a dog-like Indian, on all fours, eating grass. The style was an uneasy amalgam of Expressionist and Primitive. At the time T.C. Cannon did that picture, Scholder was painting horizontal bands of color and Matisse-like butterflies. But Scholder knew a good thing when he saw it.

Unfortunately, neither Scholder nor even Cannon himself ever surpassed the intensity of that talisman painting. They went on to appropriate elements of Francis Bacon, then became self-conscious, doing paintings that were more flat and decorative. T.C. remained more narrative than Fritz. Poorly trained in his short career, he never achieved Scholder's verve.

Not long after Cannon's untimely death, I was in Washington D.C., wandering through the National Gallery. I came across an exhibit, "T.C. Cannon and Fritz Scholder," scheduled to go to several European capitals.

EXIT TUBIS

They phased Tubis out of the Institute for American Indian Arts, giving the studio to an uninspiring Indian etcher, Grey Cohoe. Seymour and I, no longer at Jamison Gallery, both joined a co-op on Palace Avenue, where the LewAllen Gallery is now. Seymour blamed provincial ignorance and tourist commercialism for his continued obscurity.

He took a fancy to a self-portrait I did and suggested we trade. I spent excruciating hours looking through his racks and portfolios, unable to find something that grabbed me. I can't remember what I finally chose.

During Seymour's last years in Santa Fe his work was no longer in a gallery. He was always trying to get into group shows. He would choke up if anyone mentioned Fritz Scholder. By the time Tubis moved away, the art community didn't know he was still here.

THE TRIUMPH OF INDIAN ART

I ndian artists could get on one's nerves. Fritz Scholder and I were in Jamison Galleries at the same time. He was the superstar: sellout openings, glad-handing celebrities, a camera crew. He would arrive in a limousine for his opening. A man who wanted to be photographed with Fritz said, "Do you mind if I touch you?"

Jamison also exhibited two of Fritz's students, Kevin Red Star and Earl Biss. Like Scholder, they did big, dashing pop images of the Noble Savage. Their openings featured a bartender in a red vest. The artists would be surrounded by a mixture of young Indians, dressed partly like slum kids and partly in traditional gear, and waspy old Indian lovers. Red Star and Biss shows would sell out in two hours, and then Margaret would take everybody to a big dinner party in a fancy restaurant.

The last Earl Biss show was the most garish. He painted the whole show in less than two weeks, just before the opening. The twenty huge canvasses were still wet. Every canvas featured a sloppy rendition of Indians on horses in the middle of a maelstrom of drips and splashes. At the crowded opening an artist I knew backed up against a painting and got paint on his jacket. He gamely claimed

to be proud of it. Biss reserved the Casablanca nightclub across the street, where the party continued. It was that same club where not so long earlier we had had our armory art auction.

T. C. and Earl, **Eli Levin, 1976, Oil, 40 in. x 42 in.**
This painting of the painters Cannon and Biss is derived
from a scene I saw in Jimmy's Tiny's Lounge.

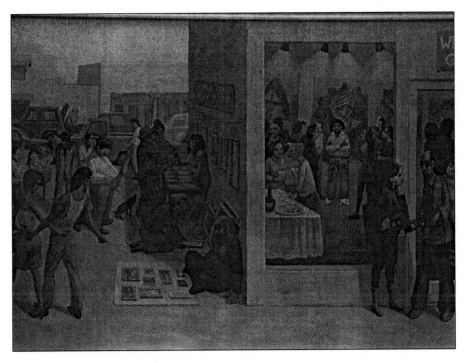

Triumph of Indian Art, **Eli Levin, 1991, Oil, 30 in. x 40 in. Collection of Charles Wessler. The 'haves' and 'have-nots' of the art world.**

When Jamison Galleries launched these Indian artists there was still a vestige of the staid old gallery atmosphere. As soon as they had their sell-out shows, they all moved on to flashier venues. Scholder, Biss and Red Star (who had a coral star embedded in his tooth) defected to the Elaine Horwitch Gallery. Having thrived in Scottsdale, Horwitch had just opened her upbeat Santa Fe branch.

Fritz Scholder became the star of Horwitch Gallery, and Elaine was so happy she gave him a sports car. Then he declared he wouldn't exhibit in the same gallery with his imitators. Biss and Red Star had to go. Their careers never fully recovered.

FRITZ SCHOLDER

I had already heard about Fritz and seen his work before I met him, of course. The Museum had two new acquisitions, his "Indian With Ice Cream Cone" and "The Staff at the Institute of American Indian Arts."

The government sponsored a week-long seminar on Indian culture at the I.A.I.A. This included a visit to Fritz's studio. Romona, Fritz's auburn-haired wife, served hors d'oeuvres and punch while Fritz talked about himself. There were drawings, prints and the new book on his graphics that the guests could buy. He gave everyone a free poster, "Indians Forever," featuring an expressionistic Indian face.

At one of Margaret Jamison's parties, Fritz and I came into closer contact. He was pontificating to a group of admirers, "If an artist hasn't made it by the time he's thirty-five, he never will." Scholder and I were both then thirty-four.

Scholder appeared ageless. He had the aura of a magus. His face was an expressionless mask. He didn't seem to move. In fact, his left shoulder was underdeveloped and his arm crippled, I think since birth. He had such poise that few people noticed.

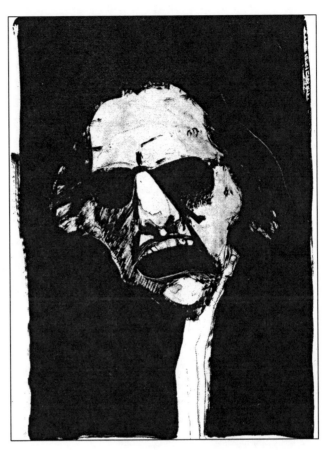

***Screaming Artist*, Fritz Scholder, 1971,
Lithograph, 30 in. x 22 in.**

I got an idea for a painting, "The Santa Fe Art Scene." It would depict Fritz on the top of a heap of artists. At the bottom was a dungeon crowded with failed painters. The hopefuls were scrambling upward to where an art opening was taking place. Scholder, top center, would have on either side a museum director and a gallery owner, both grabbing his private parts.

Santa Fe Indian, Fritz Scholder, 1973, Lithograph 30 in. x 22 in.

The Santa Fe Art Scene, Eli Levin, 1978, Egg tempera, 30 in. x 24 in.
This is the second version, the original having disappeared into Fritz
Scholder's collection. He is depicted here top center, at a vernissage.
Down in the dungeon on the right I am holding a rejection slip and
banging my head on the wall. Photo by Richard Faller.

A complex scene with about forty figures, it took some weeks to paint. As soon as I finished, I brought it down to the Jamison Galleries to show Margaret. She loved it. "Leave it here. There are some people I'd love to show it to."

The next day Margaret sang a different tune. "You'd better take it home. Bob Ewing (the Museum director) saw it and didn't appreciate it." That same day, I got a phone call from Scholder. He wanted to see the painting. He came to my studio that very afternoon. I brought out the painting. He was silent. Then, without expression, he said, "I'd like to buy it. How much is it?"

I hadn't given the price a thought. After an embarrassing hesitation I ventured eighteen hundred dollars, the highest price I had ever asked.

"I'll send my assistant over with a check; will you be here for the next hour?"

I was. The assistant, Allen Harrill, came in no time. He gave me the check and took the painting. To my knowledge, no one has ever seen that painting since, even though there was a museum exhibition of the Fritz Scholder collection.

I had some drawings in which I had worked up the idea, and a clumsy slide I'd taken. Eventually I painted a second version. It came out quite different: less fierce, more unified. It was done in tempera, while the first was oil. By then I had thrown away the photos I'd used as references. Except for Scholder, I made the characters less identifiable, such as Ewing, who was no longer the Museum director anyway. The second version of "The Santa Fe Art Scene" has been exhibited several times over the years. I also did an engraved version that had a flurry of sales to gallery owners. Jamison and Horwitch bought copies.

More than fifteen years later, a curator from the Phoenix Art Museum saw this second version along with other paintings of mine at Mayans Gallery. He included six of my paintings in a new talent invitational. I went down to Phoenix for the opening. Right away, I saw Scholder standing as rigid as a totem in the middle of the big Museum space. I had forgotten that Fritz had a home in Phoenix, as well as one in Galisteo and another in New York. I went up and we shook hands.

Then my faux pas dawned on me. Its extent became apparent when some reactionary looking Phoenix VIPs congratulated me on my put-down of Scholder. They went on to complain about how they had made him famous and then he dumped on them. I had been set up.

In Santa Fe I received a review packet from the Museum. Three reviews mentioned me, all of which lambasted my work and questioned my character for including the Fritz picture. The curator was fired.

A CALAMITOUS PANEL DISCUSSION

T he second October Festival of the Arts sponsored a panel discussion of contemporary art. It took place at the Museum of Fine Arts, in the Saint Francis Auditorium. Fritz Scholder and I were among the five artists seated at the table on the stage. Forrest Moses was another. Bob Ewing was the moderator.

An art scandal had just erupted at the Museum that very week. The Museum director, Don Strel, had gotten caught in the crossfire between the "avant garde" and the Board of Regents. Strel was the director who had cooperated with our artists' group; he put on five of our suggested shows. Now he had approved another innovative idea, an "Installations" show. It was the brainstorm of a young assistant curator, MaLin Wilson. She was a Soho type, skinny, intense and modish. Several of the ten artists she picked were doing variations of Texas Funk, a current phenomenon. Five of the exhibitors were in Hill's Gallery, our town's most serious contemporary venue. These were strong artists, including a couple of well-known Los Angeles transplants, Larry Bell and Ken Price.

The artists submitted their proposals for installations and were

accepted. The opening was to coincide with the Arts Festival. Artists started setting up their "environments." Two installations, at least, had erotic components. Carl Johansen's set-like display had numerous cutouts of bound and mutilated men and woman. Surprisingly, these apparently were not the problem. Brad Smith brought in two life-sized rubber men. Between them ran a thick hose, projecting from the loin of one figure, snaking around on the floor, then ending in the rear of the other figure.

The day before the intended opening, Don Strel saw Smith's installation and vetoed it, saying that the Museum was a government building, open to women and children. Brad's piece should be placed in restricted viewing. Strel even suggested putting it in the men's room.

Brad Smith refused to compromise, and took his sculpture back to his studio. Five other artists refused to exhibit without Smith. The show was canceled. MaLin Wilson was fired.

At this point came our panel discussion on Contemporary Art in Santa Fe. Saint Francis Auditorium was packed, and among the audience were MaLin Wilson, Don Strel and Brad Smith. Bob Ewing, as moderator, delivered the usual platitudes and introductions. The first panelist spoke. Meanwhile, my mind was racing, pondering the irony of the scene.

Fritz Scholder spoke next. He had prepared a written statement about his career. It was a cogent, strongly worded diatribe against the mediocrity of the local art scene, which he felt was not big enough to contain his talent. He insulted the I.A.I.A., the Museum and the Arts Festival. In the future, he said, he would have nothing to do with any of them.

Of course, he was right about their low standards. However, the I.A.I.A. had created him, the Museum bought his work and invited him

to be there at that moment, and the Festival was featuring his art in a unique one-man show. (He had insisted that his paintings be hung against a purple background.)

The tension in the auditorium was palpable. It was my turn to speak. I had an outline. I said a few words about the general conflict between the tourist business and serious art. Then I abandoned my notes and brought up, as an example, the censoring of Brad's sculpture. I pointed to Brad Smith and then to Don Strel, a few benches apart in the audience, and asked if either of them would like to say something to clarify the issue. "Brad?" I queried.

"I was invited to show. I set up my installation. They wanted to censor it, so I packed up and took it back to my studio." This was a long speech for Brad.

"Don?"

Strel stood and began his explanation: his responsibility to the Board of Regents, to the state government for financing, to the public which included anyone off the street—women, children. He spoke emotionally, awkwardly. Then he started to cry. Breaking off, he sat down.

There were other statements from the audience, mostly other artists backing Brad Smith. I can't remember the rest of the panel discussion.

Don Strel was soon out of the Museum as well as gone from the art scene. He became a contractor. Since that day, the Museum has avoided stimulating exhibits of contemporary art. Their oft-stated policy is that they don't wish to cover the same territory as the art galleries.

Not long after that, Fritz Scholder had a falling out with the Horwitch Gallery. Except for Elaine's stash of his work, he no longer

exhibited in Santa Fe. In a New York radio interview, Fritz said that he was not an Indian artist. He said that he had done some paintings that just happened to have Indians for their subjects, just as he had done a series of landscapes, a series of women, a series of vampires. He was not going to paint any more Indians. Indian art was dead. Anyone who went on painting Indians, after he had stopped was not a serious artist.

I happened to be visiting New York and heard the interview. I also saw Scholder there. I was across the street from Pearl Paint, the world's largest discount art supply store. There was Fritz, uncharacteristically dancing down the street followed by his wife, Ramona, her thick hair flowing.

The second time I saw Fritz in New York I was gallery hopping. I stopped in at ACA Gallery. This had been my favorite gallery twenty-five years earlier, and had shown many of my favorite left-wing realist artists. I had dreamed that someday I would have a show at ACA. I was rejected by them back then and again recently.

By a freak of chance, I walked in during Scholder's opening. At the street level there was a group show that included some of my old favorites. I mounted the stairs and there was Fritz, looming at the top of the staircase. Hardly anyone else was there. We shook hands, though my inclination was to turn around and leave.

Fritz was as deadpan as ever. Most of the paintings were of the Empire State Building, done in an up-tempo expressionist manner. The other paintings depicted lovers, somewhat shapeless. Displayed on the counter was a new book about Scholder, oversized and very glossy, published by Rizzoli.

I might as well wind up my dour reminiscences of Fritz Scholder on a negative note. An art magazine listed the ten most kitschy artists

of the year. Scholder was there in the company of Leroy Neiman and Simbari. I went to the Whitney Annual. Wandering through gallery after gallery, I could make no sense of what I saw. In the last room, just before the exit, was an installation done by an anonymous group called the Arts Coalition. The floor, the walls, even the ceiling were crammed with objects that could only be valued by a third-world bastardized culture: cheap appliances, gaudy plastic gadgets, auto accessories, a ghetto blaster, comics, amateur art, news clippings. Practically the only painting, high up in the far corner, was a Fritz Scholder Indian.

LOUIE EWING

L ouie was a close friend, like a father to me. We often painted landscapes together. Because of Louie I felt connected to the old Santa Fe art colony. When he died, his widow, Virginia, asked me to sprinkle his ashes at our favorite painting spot up in the mountains at Tesuque Runoff. Louie had loved the aspens there. Then Virginia and I had a misunderstanding. Louie and I never made that last trip.

Louie Ewing had been a young companion to the old generation of Santa Fe artists, just as I was to him and some of his contemporaries. John Sloan and Gustave Baumann gave him lessons. Louie was contemporary with the Cinco Pintores: Ellis, Bakos, Shuster, Nash and Mruk.

Ewing played straight man to the antics of Morang, Kalussi, and Macaione. Eventually he watched the whole art colony collapse. He saw the older artists phase out and his middle generation give up or move away. Louie kept his integrity and quietly continued doing his art.

He lived right around the corner from me on Camino San Acacio, but I had never heard of him. He wasn't mentioned in Edna

Robertson's book, *Caminos and Canyons*, that described the art colony up to 1945. I found out later that Louie and Virginia had been major sources for the information in book, though he wasn't acknowledged as one of the artists.

Louie Ewing.

One fall afternoon I set up a folding chair on a strip of land along San Acacio, with my back to the fortress-like wall of a house. I started a watercolor looking up the street. A man in a grey raincoat and brimmed cloth hat approached from behind me, having come around the wall where the paved steps led to a solid wood door.

"Nice view to paint," he said simply, and then walked on, right into it. He was so simple and straightforward looking, an anonymous middle-American type, old but healthy with handsome chiseled

features. I would never have guessed he was an artist. I learned later that he had grown up on a farm in Idaho and went through college on a baseball scholarship.

I was still working on the watercolor when I saw him way down the street, coming back. As he approached, it started to drizzle. He introduced himself, said he was an artist and invited me in to see his studio and wait out the rain. It wasn't a house that anyone would notice from the street. It all faced inward, concentrated around a patio with a tiered garden, shade trees and a steep, craggy hill beyond. Louie had designed and built it all. At the end of the patio was the wooden door we used to come in. There were two other doors onto the patio (or zaguan); one led to the main part of the house, the other to his studio.

Ewing's house had been thought out and built in a straightforward, comfortable and inexpensive way. For example, the tiles in the patio and throughout the house were homemade. They were four feet square, made with simple cement, the color floated into them with earth red and ochre pigments. Louie showed me how to make them when I decided to put something over the dirt floor of my studio. It had to be done a very few at a time, over an extended period. I didn't have the patience and used flagstone, which was then fifty cents a square foot. The flagstones were much harder to lay than Louie's tiles would have been.

Another feature of his house that was characteristic of Ewing was the uninterrupted interior wall of his living room, both long and high. Louie kept the wall bare except for a low bookcase that ran almost its length, constructed of two-by-tens and cinder blocks. On the top shelf were three stacks of matted silkscreens and watercolors. This left plenty of room to separate them out and study them. The

bookshelf ended a few feet short of the back wall. There Louie kept a small selection of framed paintings stacked carefully against the wall, and an easel for viewing them. Four or five other paintings were hung on the other walls of the large living room.

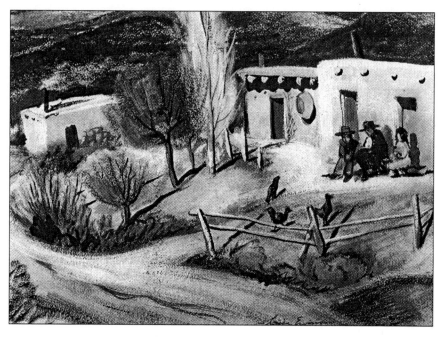

Neighbors, **Louie Ewing, c. 1957.**
Purchased by Forrest Fenn at the opening for the Santa Fe Six.

Low-key and open, the Ewing living room had a peaceful, homey feeling. There were two couches on either side of the big stone hearth, as well as some easy chairs, tables and a small piano. The big window faced the garden.

Despite its casual, comfortable atmosphere, in effect this was Louie's showroom. It enabled him to show his prints, watercolors and

oils to the public without seeming to try. He hardly ever mentioned his work unless asked. The paintings exerted their own mute appeal in this low-keyed environment. Not a few people found their way there and bought them.

Louie had another outlet for his art, also quietly effective. For a number of years he had been a foreman in the Nambé foundry. Nambé dinnerware was a favorite with the old-time tourists. In the showroom was a little bin of Louie's matted silkscreens. This one bin, long after Louie left the foundry, continued to provide the better part of his income.

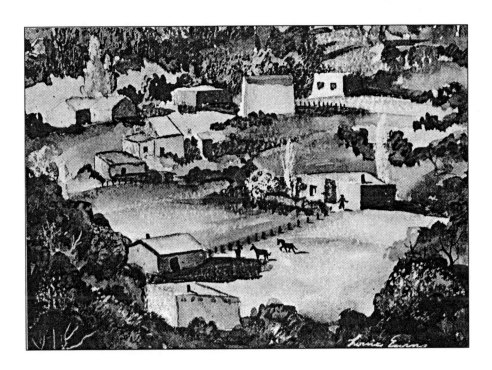

Atalaya Hill, **Louie Ewing, nd, Watercolor, 9 in. x 12 in.**
Cover image of my catalog.
This was a watercolor study for a silkscreen.

He had been doing silkscreens for over forty years, since its inception as a new print medium. He always used a painterly technique, eschewing templates and photo-derivation. Unfortunately, silkscreen as a medium underwent commercialization and subsequent loss of prestige in the art world. Louie did hundreds of screen prints over the years, achieving a masterful simplicity in recording his impressions of New Mexico. He specialized in unassuming little landscapes, original graphics that he insisted on keeping as inexpensive as posters and reproductions.

Most of Ewing's prints were in numbered editions of one hundred and twenty. A few of the small best sellers, which went as low as seven dollars to twenty-five dollars, were in unlimited editions. The all-time favorite was the kitchen saint, San Pasqual.

Louie had a story concerning this print. A Taos gallery owner had fallen on hard times. His wife had cancer, he drank and the gallery went belly-up. He owed Louie several hundred dollars. Louie went to Taos to see about it.

"I'm sorry, Louie. I can't pay you. But I'll give you something worth much more than the money I owe you: a good idea. It's this: do a silkscreen of San Pasqual, the kitchen saint."

During the years his children were growing up, Ewing worked both as a printmaker and as an artisan, mostly doing church art. Wood, stone, bronze, glass—Louie was a craftsman with all the basic materials. His studio exemplified his practical nature. The dozens of silkscreens and tens of thousands of prints were all methodically stored away in homemade cabinets, mostly hidden under worktables. Even Louie's easel was homemade. The only showy piece of furniture was an antique oak dentist's cabinet, with myriad little drawers and

cubbyholes. There were two old wooden radios—one a short wave, both still in use.

The external walls of the studio had windows carefully placed for light and a view of trees that Louie had planted just so. In the back of the studio was an alcove with painting racks above and drawers below. Oddly, there was hardly any wall space to hang paintings. A partition in front of the storage area had a small bulletin board with a few family photos, a couple of sketches and notes for projects. One of the few paintings on the wall was a portrait of Virginia, done in the early days of their marriage. Next to it was a little landscape I'd done on one of our jaunts to the Tesuque Runoff. By the door that led to the patio, on a narrow space of wall, was an early self-portrait drawing. Louie's deep-set staring eyes and the hint of radiating lines like an aura around his head showed a different Louie than was apparent in his later laconic works.

VIRGINIA EWING

V irginia had been the widow of Russell Vernon Hunter when Louie married her. Hunter was also an artist, the head of the W.P.A. in New Mexico. A couple of his paintings hung in the Ewing's entrance way. Vernon Hunter's style had some of the same elements as Ewing's, and people often mistook their works. To confuse matters further, Louie had done several silkscreens from Hunter's paintings, one of which also hung in the entrance way.

Because of Russell Vernon Hunter, Virginia knew at least as much about the old art colony as Louie did, but she had a different slant. More acerbic, she told stories of backbiting, grubbing and ineptitude.

Louie was never judgmental, except by omission. For instance, they expressed themselves differently on the subject of Alfred Morang. "Alfred was no artist!" Virginia would proclaim. "Russell wouldn't put him on the work project. Why should he?"

Louie also had a low opinion of Morang's art. In fact, after Morang died, Louie threw away all the drawings and watercolors he'd bought from him out of sympathy. "Morang was always carrying

around his old portfolio, even when he was invited to a party. He pulled out all his work, trying to sell it and embarrassing everybody." Instead of giving Alfred cash for his art, Louie would put the money on account at Tito's Market, "for food only."

Louie and Virginia Ewing in front of my house.

WHERE TO PAINT

E wing was an authority on the most picturesque painting locations. We'd drive off in his old Valiant, headed out to what seemed like the middle of nowhere. Suddenly all the landscape around us would fall into a perfect pattern. Louie would pull up at some isolated spot, pleasant enough for a picnic. The view inevitably offered a synthesis of the whole locale so that it already seemed half painted. These spots were so like Ewing paintings that it was hard for me to see them afresh. I did end up with some saleable work. There were the golden cottonwoods by the Rio Grande, the church nestled among the adobes in Galisteo, the rows of shacks in Madrid, the rock formations at Echo Canyon and the Cerrillos Flats, complete with windmill. A few days after each outing, there would be Louie's painting, framed or matted, in his living room as if it had always been there.

On our jaunts Louie always had the perfect lunch. His sandwiches were cut in exact halves, wrapped in waxed paper. A separate little pack held carrots and celery sticks. He had a big thermos of hot tea, with an extra cup, and then there were Oreo cookies. He had

enough of everything for me, too, though I tried to grub up my own stuff.

Louie painted in a leisurely way and would put in the finishing touches just when the afternoon light was mellow. Then he'd wait for me to finish, sitting quietly as if he had all the time in the world. Other artists sometimes came along, but had difficulty getting into the rhythm.

Carol Mothner, using oils, worked too slowly, though she and Louie got along famously. She brought out the gallant in him. At Echo Canyon, Louie and I set out our watercolors on shaded picnic tables. Carol sat on the hood of her car, baking, because the view was just right from there.

Sam Scott came along to Tesuque Runoff one fall day. We set up on the high side of the road, into the aspen grove, surrounded by a maelstrom of color. Louie and I had our efficient French easels, while Sam had a huge pad of paper and some clumsy, cheap watercolor set. Louie and I were slow to start, trying to make some kind of sense out of the riot of orange, purple and grey. Sam, off by himself, slashed around with his huge Japanese brush. Before the first hour was up, the ground around Sam was covered with sheets of watercolor paper like leaves falling around a tree.

"I got some good ones. What do you think? We'll have to do this again." He was done. We suggested that he go for a walk.

AFTERNOON VISITS

L ouie's light grey Valiant was ageless, not fancy but reliable, just like him. "My mechanic told me," he joked, "just never open the hood.'"

Virginia had a grey Volkswagen Beetle, also ageless and reliable. The two cars sat side by side in the carport beside the house. I would often smile at the domesticity of it, as I walked past the cars on the cement tile pathway that led to the patio entrance.

After a day in the studio, I'd visit the Ewings for tea. The first years Maria and I, and then later, Sarah McCarty and I would go. Occasionally, I'd bring along other artists of my generation. Then Virginia would serve little homemade hors d'oeuvres and pastries. Otherwise, it would simply be cookies.

We'd sit on the two couches that flanked the big fireplace. They never had a fire because Virginia thought it would make things dirty. Virginia sat in her favorite chair next to the couch. She often took nips of sherry, or maybe it was bourbon. She kept her hands busy doing needlepoint, sometimes of Louie's silkscreens.

Twilight set in as we gossiped. Louie and Virginia claimed to

have abjured the ongoing art scene, but they were interested. At one point, Virginia was considering writing a letter to the newspaper to suggest that the Fine Arts Museum should close, as it didn't do anyone any good. We'd discuss artists of their generation, or those in our immediate circle. The other exhibitors at Mayans Gallery, besides Louie and I, were Arthur Haddock, Ralph Leon, Whitman Johnson, David Barbero, Carol Mothner, Kathy Folk-Williams, and David and Kathleen Pearson. We never tired of analyzing our Vollard, Ernesto Mayans, and his protégé (after she and I broke up), Maria.

Often Louie would invite me into his studio to look at something he was working on. If someone new was visiting, he'd show them around and explain the silkscreen process.

I learned the method from Louie. The first print I did with his assistance, "Lonely Bar," came out pretty nice. It took me twelve colors, whereas Louie usually used five to seven. He was very patient, contriving to make the process seem simple. My next print, also done in his studio, was "T.C. and Earl." It came out even better. I sold or traded all twenty-five copies.

Then Ewing helped me set up my own equipment in my studio. I did five more silkscreens. Each one got worse. I had registration problems, blotchy printing, all kinds of aesthetic problems. After a few years I gave up and sold the equipment. When Louie died, I still had one of his print drying racks, which I had always meant to return. It was an upright contraption, about six feet tall, with double rows of spines like fish bones on all four sides. That was an awkward and depressing moment when I brought it back to Virginia.

EWING'S PERAMBULATIONS

When Louie drove through town, he had his own peculiar routes. I'd get nervous, thinking he was lost. But he explained that he disliked and avoided the new roads.

Every morning Louie walked downtown, a long distance, to pick up his mail at the main post office. In his last years he drove as far as Kaune's parking lot on Paseo de Peralta, and walked from there. His walk took him right by the art museum, but he hadn't entered it in years. I dragged him in to see a show I thought he'd like. Inside we ran into his neighbor, another old artist, Eliseo Rodriguez. They both looked sick and embarrassed. They were like zombies wandering in a mausoleum. What was this modern art to them, compared with the old days when they were in most of the exhibitions and won awards? In their time the museum had continual alcove shows, when the artists had little one-man exhibits for the asking and could keep up with each other's work.

Louie had a story about one of John Sloan's alcove shows. Sloan was getting ready to hang his paintings. They were ranged around the alcove, leaning against the walls. A dog wandered in, sniffed around and proceeded to piss on one of Sloan's pictures. John Sloan turned to Louie and said, "My first review."

EWING'S HEALTH

Louie was a very strong man. Once, when I stopped by I asked him to help me lift and insert a heavy beam. I was enlarging a room. We raised it up a ladder, one rung at a time. I realized he was doing most of the lifting.

Doing the silkscreens, one couldn't stop in the middle of the edition. I would have an aching back after twenty-five. Louie's editions were a hundred and twenty.

When he had a cancer operation, it was hard to accept the fact. He and Virginia minimized it. It was a little cyst in his prostate. Most older men had prostate problems. Then came two years of slow decline. The changes were almost unnoticeable, but inexorable. At tea he'd move from the couch to an easy chair and put his foot up on a bolster. His ankle was swollen. He seemed interested in the conversations in his usual laconic way, but he didn't talk as much.

Time dragged slowly on. After a final stint in the hospital, Louie returned to a special bed installed in his living room. Incredibly gaunt, his face had something of the spectral look of his early self-portrait except that the gaze was now inward.

SOME LAST WORDS ABOUT EWING,
AND A FEW OF HIS ANECDOTES

L ouie was too ordinary, too mild-mannered, to shine in the art world. His simplicity was easily overlooked, but it was exceptionally rare. His sense of balance, of repose, of a job well done, his reliability, fairness, unshakeable integrity: these qualities came from his inner strength.

The Brenheiser Art School moved to Santa Fe from California and became the "Hills and Canyons School of Art." It prospered during the G.I. Bill. Ewing came with the school, one of their star students. He became a teacher, and married the director's daughter. She had a brother who had the art supply store in town: Brenner's. It flourished between the era of Collector's Corner and that of Artisans. Oddly, all three art supply stores were run by male couples.

When Janet Lippincott came to study at the art school, after driving an ambulance in the war, Louie was one of her teachers. "She asked me," Louie said, "How do I go about painting abstractly?' So I told her, 'Just scribble, and then fill in the shapes with color.'"

Another of Louie's stories concerned Lilik Schatz, an Israeli artist. Coincidentally, I met Schatz in Israel; he was a friend of my father. When Schatz heard I was from Santa Fe, he said he'd been here

and asked after Louie. I told Louie I had met Schatz. It turned out that Louie had taught Lilik Schatz silkscreening. Schatz had used the process to illustrate a book for Henry Miller, who was his brother-in-law.

Louie and Lilik would sometimes take off for the day and drive up into the mountains to paint, to the same spot: Tesuque Runoff. They brought along a picnic and plenty of wine. Furthermore, they packed in a wind-up phonograph, lunching and painting to classical music.

Louie was a pioneer in the development of the silkscreen process. He gave suggestions to the companies that manufactured the materials. Louie developed his silkscreen methods in the 1940s because he wanted to improve the range of color illustrations for the American Index of Design, a W.P.A. project. For the index he did some of his most stunning early prints, depicting Hispanic santos and Indian artifacts. Then he went on to illustrate anthropological texts, depicting sand paintings and Navajo rugs. He achieved superb color and amazing delicacy.

In the various Santa Fe galleries I would come across silkscreens by other artists that were reminiscent of Ewing's. When I'd mention them to Louie, he'd invariably say, "Oh yes, he did a few with me."

Louie was amused by the idea that an artist's creative expression was often the opposite of his personality. He often reminisced about a painting companion from his student days, a fat giant of a man who painted tiny pictures of delicate flowers.

Another of his anecdotes concerned a comment by Gustave Baumann. They were painting together. Comparing their efforts, Baumann, a generation older, pointed out that Ewing's had too many details. "Yours is a picture, Louie. Mine is a painting."

John Sloan gave him an even more drastic lesson. At the end of a long painting session, Sloan took a rag and half obliterated Louie's efforts. "Now you have something to work with."

One of the last stories Louie told me concerned a trip he took back to his hometown in Idaho. He was painting a landscape and a farmer who was watching said, "Do you mind if I ask something? Why do you paint the trees on the mountain blue, when everyone knows that they are green?" Louie explained, as clearly as he could, about aerial perspective. When he finished, the farmer admitted that now he could see that the trees on the mountain really did look blue. To Louie, that was what art was about.

ARTHUR HADDOCK

Arthur Haddock was one of the last old-timers, whose art I grew to love. I only got to know him when he was in his eighties. I first heard of Arthur through John Fisher, my partner in Graphics House. John hung some little drawings and watercolors of Haddock's in the back room where he lived. The pictures were very low-key and hardly went with the Ettenbergs and Newmanns I was featuring. Fisher kept telling me about this old recluse, but I didn't listen.

I found out later that the pictures John showed me were part of a massive purchase from Haddock that John had acquired in collaboration with Jim Parsons and Gerry Peters. They had bought over a hundred watercolors at ten dollars each. Then Haddock had an off-season show at Jamison Galleries, barely advertised with a junky black and white flier. Only twenty to thirty people were at the opening; the big room felt empty. There were about fifty small paintings, poorly displayed and mostly in secondhand frames and crooked or old mats. The prices were low, about one hundred and fifty dollars to five hundred dollars. If by some miracle the whole show had sold, it would hardly have brought the price of one Fremont Ellis, Haddock's contemporary and friend.

**Arthur Haddock, c. 1975.
Photo by James Parsons.**

Haddock's simple landscapes were everything that the usual Jamison artists were not, a quiet rebuke to all the hyped-up Southwestern art. There were oil studies of the Taos Mountains in 1939, and works from almost every year after that up to the present.

Arthur and his wife Ira were standing against the back wall, as rigid as marionettes. They were a handsome couple, but in the bright light they looked like fossils. Zeb Conley, who owned the gallery since Margaret Jamison had passed on, introduced me to the Haddocks. Arthur shook my hand with his bony, cold fingers. He wore a black suit that hung loose on him, a sweater vest and a string tie. As it turned out, he always wore the same outfit. "He looks like an undertaker," Louie Ewing often commented.

As Arthur stared dolefully past me, I said I loved his work and wished I had money to buy the one in the window, a full sheet

watercolor of a big, sweeping desert view with a road cutting through it. In his slow, cadaverous voice he thanked me, but he seemed embarrassed to talk about his work.

Taos Morado, **Arthur Haddock, 1930, Oil on canvas, 16 in. x 20 in.
This painting was in the Jamison Exhibition.**

I went back to the gallery several times to look at Arthur's work. A couple of years later, when I was friends with the Haddocks, I managed to track down that big watercolor and buy it. Arthur told me that Forrest Fenn had it on consignment, but I discovered he had lent it to a woman named Maya who had a jewelry shop in the Inn at

Loretto. I went into the little boutique and there it was, surrounded by all this glittering ostentation. The price was five hundred dollars, which included a terrific gold frame. This was a lot for me to pay, but it was nothing considering the quality of the painting.

Soon I was coming across Haddock's paintings everywhere. Most of the traditional galleries had a few stashed away in the closets or hung in odd corners. Parsons had a huge pile of them, unframed, most still with the brown tape Arthur had used to hold them flat to the board. Parsons was charging from seventy-five to one hundred twenty-five dollars. I bought and traded several.

Arthur and Ira were living in the Castillo Apartments, a retirement compound across the street from the Post Office. It was a drab block of pre-fab two-story fake adobes surrounded by cars. The Haddock apartment had small rooms with low ceilings. It was crowded with the heavy furniture from their previous homes.

We sat in the living room. Arthur talked and talked. During almost three hours, Arthur and Ira never offered me or my girlfriend a glass of water. That room was stuffy, kept at about eighty degrees. Several terrific paintings were hung over the couches, heavy chairs and grand piano.

Arthur spoke slowly, enunciating carefully. It seemed he had total recall. There was a laconic lack of emphasis that took some getting used to. I hardly interspersed a word. His stories ranged back to 1900, when he was five years old.

After a few visits, Arthur took me upstairs to the little guest room he used as a studio. There were paintings stacked everywhere: on the single bed, the bureau, the desk, in drawers, overflowing the closet, against the walls. The visits became habitual. I'd make an appointment in the late afternoon, once a week or so. Often I'd bring

a friend, and sometimes one of us would buy a small painting for fifty or a hundred dollars.

Haddock's history slowly unwound. Particular memories set him searching through various stacks of paintings or stashes of memorabilia. The materials of his long life were crying out to be documented. He had stored them all away, outwardly leading a very private, obscure life. His dealings with the art world had been tenuous for many years.

Caliente, **Arthur Haddock and Maynard Dixon, 1930, Oil, 16 in. x 20 in.**
This painting hung at the foot of Arthur's staircase.

In the 1920s, Haddock had idolized Maynard Dixon. They often painted together, Dixon giving pointers to the younger artist. Now, fifty years later, dealers would ask Arthur his opinion on paintings attributed to Dixon. Even so, most Dixon fans have never heard of Haddock.

Arthur had his paintings in a Taos gallery in the 1950s, but the Taos artists asked the dealer to drop his work because Arthur lived in Santa Fe. The artist he was perhaps closest to in Santa Fe was Fremont Ellis. For years he had done Ellis' framing, often ordering five hundred dollar Heydenryk frames from New York. Ellis and Haddock's personalities were opposite. Ellis was as light as Arthur was dark. Fremont Ellis did not hesitate to criticize Arthur's art, which he felt was murky and clumsy. "Fremont thinks I'm a hopeless case, doesn't like my things at all," Arthur would comment ruefully.

When seen as a whole, in his little apartment, Arthur Haddock's body of work is the record of his life. It's his legacy. He numbered every watercolor he did, up to almost 2000. If he reworked one, he put a second number on it. Furthermore, there are notebooks and record books that keep track of the places and the times, down to the hours, for various landscapes. One of Arthur's best self-portraits in oil has written on the back where and when it was painted, and how long it took—remarkably, only three hours.

Self-Portrait with Hat, Arthur Haddock, 1944, Oil on board, 10 in. x 8 in.
He wrote on the back of this painting that he did it in three hours.

THE SHOEBOX PAINTINGS

After visiting Arthur and Ira for over a year, I thought all the various stashes of art had been revealed. There were perhaps still some paintings in Prescott, Arizona where the Haddocks had another home that they were about to sell. Arthur also mentioned that there were almost a hundred pieces out on consignment with a dealer named Woloshuk. Arthur had been trying to get them back since before I knew him. Time and time again Arthur worried over all these pictures, apparently wishing he had his life's work all gathered and preserved. Surprisingly, he never mentioned the "throwaway" of a hundred watercolors to Parsons and Company at ten dollars each.

I noticed more than once that Arthur would refer in passing to "that little box of paintings."

"What box?"

"Oh, that shoebox." And he'd go on to some other memory. Was this one of his deadpan private jokes? One day he let off talking and began rummaging in a low cabinet built into the hallway at the head of the stairs. The shelves were crammed with sorted boxes and

wrapped items. On other occasions he had pulled out various boxes and shown me a railroad knife, a gold watch, old clippings, a Western paperback with a cover by Dixon: "No one could paint blue jeans like Dixon."

This time Arthur came up with "the shoebox," tied with a blue ribbon. He laid it down on the single bed in his studio and ceremoniously opened it. It was stacked from one end to the other with five-by-seven-inch thin cardboard panels, over four hundred and fifty of them, numbered consecutively on the backs. They were tiny paintings, all done from more or less the same spot. It was the view from his framing shop on Calle Peña. They were done either looking out the window or from in front of the door. Almost all were painted in the late afternoon, when he had finished work.

Shoe Box Paintings, **Arthur Haddock.**

Arthur stood back and watched, bemusedly, as I laid the pictures out all over the bedspread. One was off-size, slightly bigger. It was a beauty: two cars backed by walls and trees, all snow-covered. On the reverse side, along with the number, he had written, "Still Stench." I asked what that meant. Arthur smiled his slow, sad-eyed smile.

"You can have that one," he said. Not an answer to my question, but I didn't cavil. Later Ira told me that "stench" was railroad slang for snow, and that Arthur hated snow.

Even after Haddock let me see the shoebox paintings, he was reluctant to let anyone else know about them. They were some of his strongest works, paradoxically monumental. They had something of the breadth of Hartley or Burchfield. These little paintings were analogous to a private journal. They were done in the years of frustration when, after having built his house and studio, he had had to frame other artists' work. Whatever the reason, Haddock put them away and never brought them out again. After a while, people stopped listening to me when I described them.

After Arthur died, his wife Ira gave Mayans Gallery permission to exhibit them. It was a marvelous show, all three rooms given over to a succession of these little "takes." Ernesto designed a dramatic poster with nine of the backyard variations in three rows of three, all against black. Many of the shoebox paintings sold, at four hundred and fifty dollars each.

CALLE PEÑA

I n their living room, hanging over the couch, was one of Haddock's few full sheet watercolors. I often studied it as I listened to Arthur, and could almost feel I was walking into the scene. It depicted a spot just three blocks from my house, the junction where Acequia Madre becomes Camino del Poniente and Abeyta comes down to meet them. Veering off to the right is Calle Peña. A few doors down, just out of the picture, would be Arthur's house. This was a spot I drove through almost every day. In Arthur's painting it was moody, even slightly desolate, with an intimate feeling. He had even included a little figure going down the street, very unusual in his work. To me it was one of his best paintings, like a Burchfield but more personal.

Arthur would catch the direction of my glance and launch into a remarkably dense reminiscence of the people, including Max Eastman, who lived in the four or five buildings visible. There were generations of friendships, marriages, divorces.

One early fall day the three of us climbed into Arthur's big Oldsmobile and Ira drove over to the very spot. We turned into Calle

Peña and went right up to what had once been their gate. We sat there for a few minutes as if confronted by a time warp. Then Ira and I went in and knocked at the front door. When a middle-aged woman opened, we explained. She was receptive, and invited us all in.

The main room was not as large as I had expected. It had a high ceiling and a big window on the north, a traditional studio. The bedroom was on the balcony, with another room under it. The kitchen was tucked partly under the stairs. The most Haddock-like touches were in the detailing, done in simple wood. Under the stairs, which came down one side of the kitchen, Arthur had built cabinets with triangular drawers to match the rising slant.

In the yards were huge fruit trees. They looked like they'd been there forever, but Arthur and Ira had planted them. One was beautifully placed in front of the studio window. The woman who now owned the house was very friendly. She helped us pick a bag full of apricots.

From under the apricot tree in the front yard, I tried to identify the scenes of the shoebox paintings. Calle Peña was paved, there were new houses, carports, many new walls, and of course the trees. It felt like the right place, but I couldn't find one landmark from the four hundred and fifty paintings.

However, I had a quite different jolt of recognition. To our right was the block-like building that had been Arthur's frame shop. I remembered having been here before. In the late 1960s, I had been trying to scrounge up equipment to make my own frames. My framer, Bob Stothard, told me he knew an old guy who might have some spare moulding. We had come here. I now realized it was Haddock who had opened the door of the gloomy, dark shop. He had been negative and

abrupt, and I barely had time to peer past him into the fascinatingly old-fashioned, meticulously arranged shop.

Arthur was always obsessive about using quality materials. His ancient tools were kept in perfect condition, and he had many more materials than he could have used. He also stocked quality art supplies. He had enough watercolor paper for five lifetimes.

I never understood why they sold the place on Calle Peña. Perhaps they needed money for his cancer operation. Or was the retirement place easier to maintain? Then, too, they bought the house in Prescott. Was this because they were disillusioned with Santa Fe? However I broached the subject, I never got a straight answer. Since Arthur died, Ira has mentioned that they fought and had troubled times during their first years at the Calle Peña house.

The Prescott home, which they maintained for eight years while traveling back and forth, also proved problematical. The paintings that Arthur did in Arizona, full of Cezannesque foliage, are uncharacteristically tentative. There are dozens of versions of the view from the Prescott studio window: a diagonal road in the foreground, a heavy body of slanty pine trees in the middle, and two hills with a water tank between them in the background. A lot of those went into the ten-dollar-a-picture deal.

POST OFFICE PAINTINGS

Those Prescott paintings, not entirely successful, were at best trial runs compared with the later series of window views Arthur did in Santa Fe from his second floor studio in the Castillo apartment, across from the Post Office.

The literalness in the Prescott work couldn't be more different from the amazing transformation Arthur wrought on our ugly Post Office.

The view from the window was terrible. The Post Office has a 1950s cheapness, a hybrid, institutional look. Tired-looking trees partially obscure it, and in front of them are parallel-parked cars. To the right, the street recedes into the distance. On the far side, a bigger parking lot is blocked periodically by trees. Beyond the lot are three or four buildings that used to be the high school complex. During the years Arthur painted them they were first abandoned, then refurbished as government buildings. In the distance are the gentle swells of Sun and Moon mountains.

Haddock painted more than seventy variations of this scene. These are among his last paintings. They are curiously influenced by

Gauguin, and also slightly by Utrillo. Arthur had books on both artists near at hand, and he didn't have many other art books. The paintings have a mood that is often close to Edvard Munch, a condensed brooding. They depict a small town worn by the elements and much lived in, portrayed with claustrophobic intensity.

Arthur denied any interest in Munch. I couldn't be sure he knew who Munch was. Burchfield drew a negative response, too, to my surprise. His other art books were on Van Gogh and Cezanne. The only fancy art book he had was on Maynard Dixon, and there was also a smaller book of Dixon's drawings. There were old pamphlets and catalogues on several California painters, mostly watercolorists.

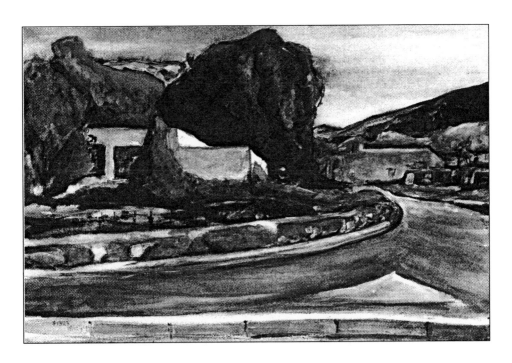

Federal Building #1323, **Arthur Haddock, 1979, Watercolor, 15 in. x 22 in.**
A view of the Post Office from Haddock's studio window.

HADDOCK'S THINGS

Arthur made almost alchemical experiments with materials. There were many tiny jars of various mediums, hand-labeled. I still have five of his funny little bottles:

1. Emul Wax, let stand in light to see if darkens
2. Feigenmilch (artificial) Weimar Colors
3. Feigenmilch (artificial) by myself
4. Harzmal mittel
5. Sperm oil

Tiny notes, scribblings on scrap paper, would turn up in drawers slipped between stacks of pictures or under art supplies. Some were technical jottings, such as "Add a touch of Damarr to Hide glue for gesso." Others were too complicated for my comprehension.

Interspersed between pages of the art books were other little notations: quotes, cryptic statements such as "Keep the darks simple," or "The Big Vision, eliminate all else."

HADDOCK'S DAILY JAUNT

Arthur's longstanding habit was to go out for breakfast. He would walk to whichever hotel coffee shop was his favorite at the time. He voiced unending complaints about the inability of the various restaurants to fry eggs and to hash brown potatoes. He was probably trying to match some distant memory from his railroad days. After his breakfast he'd stop in at galleries that had one or two pieces of his work: Jamison, Woody Wilson, Fenn. He'd sit quietly in a corner, watching the tourists come and go.

NICK WOLOSHUK

Nick Woloshuk dealt art behind the scenes, through other dealers, though for a while he had a little outlet in Santa Fe Village, an arts and crafts center he owned. Time and again Arthur would review the most minute turns and twists of more than fifty years of his career, but when he got to Nick Woloshuk, the narrative floundered in confusion.

Nick Woloshuk had encouraged Arthur at a low point in his career, most likely at the time of his bout with cancer. He gave Arthur bits of money on account, totaling around eighteen hundred dollars. This once, Arthur didn't keep a record. This was a source of much perturbation as he tried to reconstruct what had taken place.

Several years had elapsed since the initial deal, and Nick visited less and less frequently. When he came by, he didn't settle accounts but kept the conversation friendly and solicitous, adding a lot of pious homilies. He was a born-again Christian. If Arthur became insistent, Nick would acknowledge a sale and give Arthur a couple of hundred dollars, which confused matters still further.

I met Woloshuk once before I had heard Arthur's story. I had wandered into Santa Fe Village. The building had formerly been

a huge garage-like structure that once housed the Motor Vehicle Department. After they moved out and the building had been empty for years, Woloshuk remodeled it, hiding the old structure under a lot of faux-crumbling adobe and old wood. Chunks of plaster were purposefully missing, bricks artfully exposed. Inside, it was portioned off into a rabbit warren of little stores divided by exposed adobe walls: Santa Fe's first mall.

As I wandered toward the back, I saw a small space with a sign, "Going out of business." I peered through the plate window. Amid the usual Indian rugs and pots, I noticed some matted drawings that looked like Morangs. The door was locked. Inside there was a pot-bellied, surly-looking man. I knocked and gestured at the pictures. He begrudgingly opened the door. The Morangs were good ones, from the "Women of the Night" series. He only asked twenty-five dollars each, a very low price. I bought three. I knew he must be Nick Woloshuk, but neither of us said anything. Though he acted indifferent about the drawings, I knew Morang was an obsession of his. There had been a big Morang revival a few years earlier, when all the dealers and runners (art dealers who had no gallery) were trading them back and forth. The paintings all seemed to track back to Woloshuk.

I went back a few days later, thinking I might buy some more. The shop was empty. In fact, he had sold the whole old Santa Fe Village. He retreated into his private life. His reputedly vast holdings of Morangs and other artists disappeared with him.

There were many rumors about Woloshuk: that he had successfully out-maneuvered Forrest Fenn, with whom he had been partners when Fenn Galleries opened; that he had dealt "Remingtons" painted by Japanese; that the remodeling of Santa Fe Village was done by teenage dropouts that he had taken in, converted to born-again

Christians and exerted undue control over.

I knew several runners. They were always coming around with paintings in the trunks of their cars. Jim Parsons, a prime example, even wrote a book on the subject, *The Art Fever*, published by Sunstone Press. John Norton, who was rumored to have helped Gerry Peters get started, was another. These runners would smile knowingly and clam up when Nick Woloshuk was mentioned.

For months, Nick hadn't returned any of Arthur and Ira's calls. They finally reached him and he said he'd come by, but he never did. They managed to reach him again and set a definite time. They waited all evening and even had cookies ready. Woloshuk didn't show.

Arthur had a small stroke. Although he was a bit slower, he was quite sharp. Ira managed to reach Nick Woloshuk, and this time he did come. Nick continued to evade Arthur's questions, only offering bland reassurances, and ended up leading Arthur and Ira in a prayer for Arthur's health!

A few months later, we were once again fretting over the hundred missing paintings. I mentioned having seen some of Arthur's paintings, along with a whole wall full of little Gaspards, hanging in the new Bank of Santa Fe. Woloshuk had hung part of his collection there. The bank was near where the Haddocks lived, just past the Post Office and the Federal Court House.

I suggested a simple scheme: we three would just go get Arthur's paintings. After all, they were his. Besides, Ira had worked in the First National Bank for years. It had been the only bank in town, and she knew several people at this new bank. Over a period of several weeks, during which Woloshuk was impossible to reach, I convinced Arthur and Ira to try my idea. We'd just go in, see what's there, feel the situation out.

The day came, and we were as excited as school children. We got into Arthur's big Oldsmobile and drove to the bank parking lot, where we found a parking place right near the bank entrance. The trip took about one minute. In we went. The walls were bare. Still, we were jolly, because at least we had tried.

After Arthur Haddock died, Ernesto Mayans did manage to confront Woloshuk. They met with Ira. Nick returned eight oil paintings, but for a fee. A couple of the paintings were excellent, but the others were from the transitional 1950s period. None of them were the ones I'd seen in the bank.

HADDOCK'S LAST DAYS

rthur and Ira went down to Prescott to settle up the house. While they were there Arthur had another stroke. He went to the hospital there and Ira returned to Santa Fe to arrange for his return. Arthur was to be flown to the Santa Fe Airport in an ambulance airplane.

Ira called me and said Arthur had requested that I come to the airport to drive him to the hospital. I was touched, and nervous about taking the responsibility. People were always joking about my old car, which had a crooked chassis and came down the street a bit sidewise. I might have gone with Ira in their car, but she didn't suggest it.

I drove out to the little airport at the appointed time. When the male nurses brought Arthur out of the airplane on a stretcher, I was shaken. He looked so emaciated and dazed. But then he sat up and, with assistance, stood. He was feeble, but seemed to understand what was going on. With the nurses helping him, he got into my car as Ira and I stood mutely by. I also got in. I said a few things, who knows what. Arthur didn't answer. He was holding a plastic jug, and had an expression of concentration.

So I started the motor and we drove to the hospital. I tried again to make conversation. I wasn't sure Haddock was listening. Just before we arrived, Arthur spoke: "I'm afraid I'll wet myself." His face showed painful humiliation.

I pulled up at the emergency entrance of the hospital. Ira got there a few seconds later. She stood by, while I ran in to get a wheelchair. Arthur managed to get out of the car and into the chair without trouble, clutching the empty container in his lap. We made it. Arthur seemed to relax as a nurse took him down the halls.

A few days later he was home and had already recovered quite a bit. The long, slow stories were slower still. Arthur retained most of his phenomenal recall, especially for early episodes. If he forgot a name or detail he would get mad, fretting over it more than he used to. The look of anger and shame that I saw on the way to the hospital stayed with him. He mentioned often that something in his throat bothered him. It was preventing him from sleeping. He was so dire about it that I couldn't help thinking of a death rattle.

Occasionally Arthur would phase out. I asked questions, I talked more. Sometimes he'd ignore me. A couple of times when I came to visit I found Arthur out front, sitting in his Oldsmobile on the passenger side. The car was parked as usual, facing their front door. The first time the car door was closed as if he expected to be driven somewhere. The second time, he had left the door open. Something in his expression made him seem infinitely far away. But he rallied, and came into the house for a visit.

LAST VISIT TO THE STUDIO

A few of Haddock's last paintings, done even later than the Post Office views, were of a one-room schoolhouse in the California hills. I asked him if that were where he had gone to school. A long pause. "Nope." Another long pause. "My mother ... my aunt."

He changed the studio around a bit. He put an old ironing board in front of his easel. On it were his watercolors, brushes, palette, sponge. The easel was a flimsy tripod type. He had several better easels. Arthur's favorite brush, which he said he had had all his life, hung from a little hook in the side of his desk, just to his left. On his right was an oversized cardboard box, about three feet high, the inside completely spattered with paint. There were dirty rags at the bottom. This was where he shook out his brushes to control the wetness of his strokes.

On the desk, as well as all around the room, were stacks of framed, half-framed and unframed watercolors. Each time I visited, this array had been reshuffled. Arthur took watercolors from various piles, or out of frames, and sponged out parts (especially the

foregrounds), then reworked them with watercolor pigment so thick it looked like pastel. He'd slip the reworked pictures under the old, thin, irreplaceable framer's glass.

When Arthur was especially happy with a picture, we'd look around for an appropriate mat and frame. I would take all the parts back to my studio, clean them up and put them together for him. Not infrequently I would find two or even three watercolors under one mat.

ARTHUR HADDOCK'S DEATH

The last time I saw Arthur Haddock was at St. Vincent Hospital. There was a trace of the rattle in his breathing. He was resigned, dignified. For a few seconds he directed a piercing look at me. Ira commented later that it had been his saying goodbye. At the final service and funeral there were few mourners. The two ministers both made the pathetic mistake of referring to "Ira" instead of "Arthur."

Ira arranged to sell the house in Prescott. A friend of hers brought up a big truckload of Arthur's art supplies and equipment. Eventually, I went with Ira to the storage locker and helped sort through everything. It was almost all art materials and framing equipment. There was an elegant easel he had built himself, and several others of antique design. There were five handmade oil paint boxes and numerous watercolor sets, some also homemade. Then there was the watercolor paper: thousands of sheets, all top quality. A small but very heavy moulding chopper was a relic from the turn of the century. There were boxes of mysterious old tools. He had a dozen glass cutting tools in a wild assortment of sizes and shapes.

I lugged all this paraphernalia into my living room, then commandeered my favorite items: the easel, a handsome paint box, a set of good oil paints, watercolor brushes that weren't too big for my work, some well-made tools. It took all day to sort and label the rest, guessing at costs, everything half price. I made phone calls to the most busybody artists I could think of, and to friends I thought deserved a good deal.

The next day was a scene of grubbiness: pushing, grasping, embarrassing bargaining. One woman, after poking around endlessly and asking for details on everything, bought one piece of watercolor paper for three dollars from a packet marked "Green's" (the best, and no longer obtainable). The next day she came back with it because it had an embossed stamp: "Grumbacher." So I held it up to the light, and the watermark was, indeed, "Green's." She gave me a suspicious look and asked for her money back.

By the third day I had fairly cleared my living room and had collected about a thousand dollars. In the weeks that followed, I sold off the watercolor paper to a few serious academic artists for a couple of thousand more.

The worst problem was the frames. Big and clumsy, heavy with plaster filigree and gold leaf, many were Heydenryks, once worth hundreds of dollars each, but were now out of style. To Arthur they were the best, and Fremont Ellis had agreed. Nobody wanted them. Several were chipped or full of tiny cracks. I had to practically give them away. I kept the best ones for Ira, later trying to find works by Arthur that somehow fit them.

Ira passed on some of Arthur's clothes to Ernesto Mayans and myself, all fine quality. Arthur hadn't worn the best things at all,

preferring his familiar, older things. I got a trench coat, an overcoat, a lumber jacket and a sport jacket that is still my favorite, although I had to have the lapels taken in.

I was a bit shocked when Ira traded in their almost perfect Oldsmobile for a new Lincoln Continental at twenty-seven thousand. Her comment was, "Arthur always said to buy the best." Once when she came over to visit me on Don Miguel, she drove into a neighbor's driveway to turn around and the new car scraped bottom. After that, Ira wouldn't drive on the dirt streets of my neighborhood. We went to lunch in my old clunker.

The next task Ira and I tackled was to try to make some order out of Arthur's artwork. There were hundreds of canvasses and watercolors tied in neat packets on the floor of the studio closet, under the clothes. I built a painting rack between the closet and the window. Most of Arthur's paintings were small, sizes that fit into four or five standard size frames. I figured out how deep the shelves should be, cut 2 x 12s in my studio, then put the boards together in Arthur's studio. The rack is still there, crammed full.

I sorted Haddock's work by quality, size, date, framed or not, oil or watercolor. I set aside the best works for framing, but Ira didn't want to spend the money. If I had had my way, fifty to a hundred pieces would have been framed. As the weeks went by, my select piles got shuffled.

I hoped to do the framing with Sarah McCarty, my girlfriend, who had set up a frame shop and now even had some of Arthur's tools. Ira Haddock and Ernesto Mayans preferred Frontier Frames. Sarah and I remained close to Ira, but Ernesto Mayans took over the merchandising.

WHITMAN JOHNSON

After my initial mistake of not picking Whitman's art for the Santa Fe Six exhibition, I would occasionally come across him, painting on location around town. His face was rough and red from the weather. The paintings he worked on were bold, pared down to the essentials. He seemed a loner, but agreed to show me more of his work.

He lived off Garcia Street in a tiny one-room apartment. The larger paintings were under his bed, smaller ones crammed in cartons. They were good. He didn't want much for them; small ones were under a hundred dollars. I bought six or seven, including a strong self-portrait. I framed some of them and Ernesto Mayans put them in his gallery at double what I paid. I didn't stand to make much profit, as Ernesto took forty percent, but I was glad to have Whitman in the same gallery I was in. The paintings were noticed, some sold, and Ernesto took Whitman on.

Whitman Johnson.

Self-Portrait,
Whitman Johnson, 1974,
Oil on canvas, 16 in. x 20 in.
I used to own this painting.

***Suburban Street*, Whitman Johnson, 1978, Oil, 11 in. x 15 in.
Back cover of the *50 Years of Santa Fe Realists:
Works from the collection of Eli Levin*.**

Whitman Johnson's paintings were heavily influenced by Cezanne. Whitman avoided the irrational aspects of Cezanne, such as the skewed perspective. I know that the cognoscenti praise Cezanne for his contradictions. But I like Whitman's work because he resolves the inconsistencies.

Whitman and I shared the cost of models that we posed in my studio. We did portrait studies of an Indian, a Spanish American, and two Anglo acquaintances, Kathleen and Beth. It took us four to six sittings for each painting. Sometimes I managed to do a quick little second canvas before Whitman was done.

**Whitman and I painting Beth
in my second floor studio on Don Miguel, c. 1980.**

*Portrait of Kathleen
Marie Richards,*
**Whitman
Johnson,** 1979,
Oil on canvas,
24 in. x 20 in.

Portrait of Kathleen Marie Richards, **Eli Levin, 1979,**
Oil on canvas, 16 in. x 12 in.
Whitman and I painted Kathleen together.

Though Whitman worked methodically, he was self-critical. He would start over three or four times, scraping down the paint surface as much as possible. He'd make radical changes in scale. He cleaned his palette down to the beautiful dark wood two or three times during each painting session. It was a small palette, the half-size that fit the narrow box of a French easel. Whitman only used four or five colors. While working he hardly talked, while I rambled on nervously, in awe of his single-mindedness. He was stolid, taciturn.

An ex-girlfriend of mine, Linda Monacelli, used to work for the Festival of the Arts. I got the idea of fixing her up with Whitman. He seemed to be a loner since his marriage had broken up a couple of years previously. Linda came to a show that Whitman was in at Mayans Gallery. She bought a canvas of his depicting pine trees leaning over a river. Linda's only other art purchase in Santa Fe had been a painting of mine, also of a stream surrounded by trees. Then, too, she wrote many poems about trees and streams.

The moral is that single women should buy paintings from eligible artists. Linda landed one in this town on her second try; she and Whitman are now married.

TIM Z. JONES

.

J ust a few of my students have continued to paint. Most don't have the perseverance.

Tim Jones vacillated but kept coming back to art. His was an easy, natural ability. He saw his subjects simply, with a touching purity, especially in the color. His touch, while beautiful, was occasionally too light, betraying distraction.

Instead of going with the flow, Tim dreamed and schemed about his career. He agonized over grandiose projects, schemes to get grants and patrons. He felt that some foundation should send him on a painter's mission around the world to depict mankind's symbolic brotherhood. Yet he found it hard to walk out his door and paint the New Mexico landscape.

Tim was in awe of successful landscape artists like Gonske and Goebel, no matter how slick their works are, trying to solicit the secret of their success. Even when he thought he was imitating their slapdash style, his paintings had an innocence and purity that showed up their vulgarity.

Tim first came for lessons wearing a turban because he belonged to an enclave of Sikhs living in Espanola. Tim, then named

Sat Tej Singh, stayed with the Ashram for eight years. The leader often ordered him to stop painting, but eventually he would sneak back into it.

Timothy Z. Jones, c. 1980

Finally he left the Sikhs and worked as a sign painter. He always had trouble finding time to paint.

Tim didn't have the concentration to follow my academic teaching. He went off to Cape Cod to study with Henry Henshe, an ancient maestro who billed himself as the last Impressionist. Henshe had studied with Hawthorne, who had studied with Chase, who knew Whistler—none of whom was exactly an Impressionist. Anyway, it is an impressive lineage.

Henshe's monitors set up still-lifes of wooden cubes, the sides of which were painted various primary colors. The tabletops were built with a lip around the edges so that the blocks could sit in a thin layer of water. All this was outside, in the sun. Tim experienced a sense of liberation in concentrating on outdoor light and color. He came back with still-lifes and landscapes, full of cadmium yellow sunlight and purple shadows. Since then his vision has bleached out, regaining somewhat the subtle beauty of our Southwest light.

Tim liked his frames heavy, bulbous, covered with silver and gold. He sank his time and money into making and buying these clunkers. His delicate tonal pictures were crushed by their surroundings.

Tim was always buying audio equipment and ever-fancier guitars, then cutting tapes of himself singing his own songs, another diversion from painting.

He had a nice piece of land out near Lamy, which he made payments on for ten years. During those years he scavenged a terrific amount of building materials and hauled them out there, where they slowly rotted. Meanwhile, he continued to live in town, and finally his debts got so bad he had to sell the Lamy property.

Tim was invariably bright-eyed and good-willed. It was sad to watch his vacillations keeping such a gifted artist from success.

Our Lady of the Light Chapel, Timothy Z. Jones, 1980, Oil, 22 in. x 28 in.

DAVID PEARSON

David and his wife Kathleen rented my downstairs apartment for five years. They were teenagers when they moved in. Dave shared my studio, while Kathleen painted in their little living room. He sculpted elegant, elongated figures. She painted naïve, detailed still-lifes and landscapes.

The Pearsons had been young lovers for several years before their marriage. Theirs was a close relationship blessed with understanding that belied their youth. Both of them had problem parents. They had become self-reliant even as children. Their perceptions of people were a great help to me. They could spot the hidden, sleazy elements. Dave was a bit like a son to me.

Dave had worked in the Shidoni foundry while in high school and after. Without ever having studied art he knew all about sculpture, especially from the technical side. He picked up some of the romance of the art world even though the shop conditions were bad. The poisons in the wax room where he worked for years gave him a continual rash.

David Pearson, 1976.

Dave became aware of the low aesthetic quality of most of the art he was working to perpetuate in bronze and hoped he could do better. While he was sharing my studio he switched from modeling, which he knew so well, to carving. This was to avoid the toxins as well as the expense of casting. I had done some wood carving. In Santa Fe there was a lot of interest in direct carving because of Allan Houser and his influence on a generation of younger Indian artists. Anglo artists sometimes worked as assistants to the Indians. Dave helped Doug Hyde roughing in, sanding and polishing, at six dollars an hour.

In the summer Dave and I carved in my yard. He wangled some nice hunks of hardwood from the I.A.I.A., unfinished pieces that had been tossed aside by the pampered students.

I was often depressed by the art world, but Dave and Kathleen gave me a better feeling

Kathleen Marie Richards, 1976.

about it. Their decent life style, their sober sincerity, the integrity of their approaches to their own art—all this was an inspiring example for me, bringing to mind the high hopes I had had in my own student days.

When their first child, Avery was born, they asked me to be godfather.

Tracy, **David Pearson, c. 1978, Bronze, 35 in. tall, edition of 15.**

Sarah's Favorite Place, Kathleen Marie Richards, 1979,
Colored pencil on toned paper, 7.5 in. x 9.5 in.
Dave and Kathleen rented the middle section of my house,
which included a fireplace that I built.

JOEL GREENE

J oel was another artist whom I introduced to Ernesto Mayans and who has since become one of his best artists. I must admit that, as with David Barbero, my recommendations were equivocal. While I respected their dedication and liked them as people, their semi-abstract work derived from artists I didn't like. Also, I didn't think Joel's or David's work would be that salable. I'm sure I said all that to Ernesto but he took them anyway, so I can't take much credit.

Joel had moved to Santa Fe after ten years at the University of Iowa—in Lasanski's famous graphics department. He called me out of the blue. He was having trouble getting acquainted with the local art scene, and he heard that I knew my way around and might be able to advise him.

My girlfriend Sarah McCarty and I both engraved and etched, and we were curious to see his setup. He had rented an industrial space and installed a shop as elaborate as that of a college art department.

Joel was a little rotund funny-looking fellow, young but seeming old, smoking a pipe. For a minute Sarah and I thought he might be a social misfit. Yet he was very well spoken. His art at first glance seemed equally unprepossessing: small, colorless, diagrammatic, emotionally flat etchings. His style was a variation on Kirschner and Leger.

**Joel Greene with Katherine Venturelli in 1985
at the New School Studios on Canyon Road.
Photo by Sydney Brink, *The New Mexican*.**

As we became acquainted, we realized Joel was a very nice person and knew more about art than most of the local hotshots. He was even a native, having grown up in Las Vegas, New Mexico, where his father taught at the University. But there was no Southwest motif in his work, so we considered his chances in the Santa Fe art scene to be nil.

He told us that he'd contacted Ron Adams, the owner of Hand Graphics, who hadn't been impressed by his work. Ron later told me that he thought Joel's prints were uninteresting. Joel knew all about printmaking but chose to pare it all down to a totally stripped, unflashy style.

Mayans must have sensed something. He ferreted out a substantial stash of Joel's old paintings, gouaches on paper. They

were much warmer and moodier than the graphics. Inexpensive, they began to sell steadily. Soon Ernesto had Joel painting. Finally he stopped etching.

Joel's recent oils, increasingly cubist, while being the gallery's most unregional work, continue to sell well. Despite having two master's degrees, when Joel came to town he supported himself for a long time by working at La Posada as a (male) chambermaid. Now he is painting full time.

Artist's Cat and Pitcher, Joel Greene, 1988, Oil on linen, 24 in. x 18 in.
Photo by Richard Faller.

OLIVER ORTIZ

Oliver Ortiz was another young artist I took an interest in and introduced into Mayans Gallery. Oliver was simian and sexy, often disarmingly honest, a hyper jive-ass.

He had a beat-up, antique little motorcycle. In the summer he rode around practically naked, wearing only a bikini bathing suit. Oliver's other vehicle was a dilapidated Volkswagen bus, covered with graffiti, ski emblems and bumper stickers. "Crow Mobile" was emblazoned on one side.

Oliver would make the rounds with sketchbooks full of expressionist landscapes done with heavy crayon. They were close in spirit to the early Santa Fe artists Morang, Macaione and Baumann. Who knows how Oliver picked up their influence? He'd hawk these for twenty-five dollars each. Ernesto and I ended up with piles of them.

Oliver did oils, too, including several big ones. He and I made a selection to take around to the dealers. He insisted on framing them with warped and weathered stripping he had in his back yard. We loaded the paintings in the back of my pickup truck and drove from his barrio hole in the wall on Closson Street to Hill's posh gallery on downtown San Francisco Street, where we had an appointment. We

unloaded the paintings one by one from my old truck and carried them into the elegant space. Sarah Moody, the modish director, along with a couple of equally suave assistants, looked on with amusement.

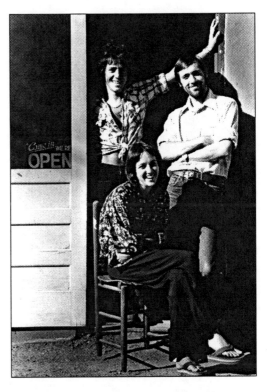

**Oliver Ortiz, Whitman Johnson, and Bonita Barlow
in the doorway of the Mayans Gallery.**

I felt a moment of panic, but the paintings held their own. They were Santa Fe street scenes, done in an expressionist frenzy. Sarah and her friends were charmed, and she offered Oliver a show. The Ortiz exhibition did take place but unfortunately, Hill's was on the decline and closed not long afterwards. Oliver Ortiz's show slid by almost unnoticed, low-budget and off-season.

**Ernesto Mayans in his gallery,
April 1985.**

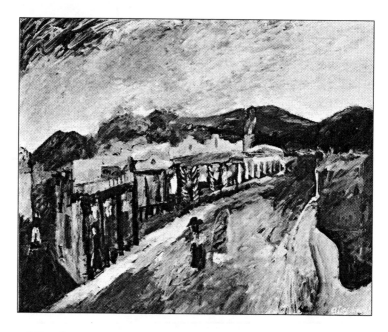

A Man from Torreon Meets a Woman from Isleta on Kit Carson Road,
Oliver Ortiz, 1977, Oil, 32 in. x 26 in.
From the *50 Years of Santa Fe Realists.*

TRUDI AND OLIVER

O ne day I was having lunch with Ralph Leon in Ernie's, a Canyon Road restaurant in a sunlit atrium surrounded by flowers and ferns with a fountain in the middle. A tiny blonde came in. Silhouetted against the sunlight, her skirt was transparent. She walked up to our table, introduced herself and said how much she liked my paintings. Then she left, giving us the back view.

At about midnight my phone rang; it was this same Trudi, calling from the El Farol Bar. She asked if she could come over. I got up and drove to El Farol to show her the way—it was just around the corner. She was sitting in her Volkswagen Beetle, waiting for me. The right front fender was smashed. She was wearing a man's shirt and tie. I said hello, and Trudi followed me home.

A couple of days later I visited her in an old adobe house out in the middle of nowhere, near Ojo Caliente. The place was full of strange, campy junk. Her paintings and drawings were quite good, very punk and fey.

The next day we came into town to attend Whitman Johnson's opening at Ernesto's gallery. Trudi drank a lot of wine. Ernesto Mayans

had reserved a big table next door at The Haven restaurant. Loud and boisterous, we all tumbled into the restaurant. Trudi sat between me and Oliver. Though they had just met, they were soon laughing and fondling each other. Halfway through the meal she dumped her plate of food in my lap. Our whole party was rowdy. The owner of the restaurant kept trying to quiet us. A few minutes later I realized that she and Oliver had disappeared. Someone from our group found Trudi and Oliver making love in the bathroom, on the floor. By the time coffee was served, Oliver was back. Trudi was gone.

Some of my things were in her car. Oliver and I went looking for her. We finally found her car not where she'd parked, but way down Canyon Road. Inside was Trudi, in a stupor. I was glad to retrieve my things, and Oliver and I helped her walk up the street to his Crow Mobile. I left them there and returned to the restaurant, where I ended up paying for all three of us and shelling out a few more dollars to cover everybody's shortfall. I walked home: peace at last.

Once at home, I had an uneasy feeling that something was wrong. I looked around until I discovered that there was someone snoring in my bed: Trudi. Oliver, you devil.

Not long afterwards, Trudi moved into a studio across the street from me. I found it awkward, but we kept in touch. She was painting enormous canvasses of anemic attenuated figures inundated in claustrophobic patterns.

Trudi dropped by one day when my cousin Judy was visiting. Judy had a disturbed son who for the last three years had been in a Texas prison for attempting armed robbery of several pizza parlors in one night. Judy had just been to visit him. Trudi, from Texas, listened sympathetically. She knew a Texas senator and, on the spot, made a

long distance phone call. Judy's boy came up for parole and he was released.

I tried to dissuade her, but Trudi destroyed all her paintings. Then she moved away. The last I heard, she was on a pleasure cruise in the Caribbean with her mother.

OLIVER'S FURTHER CAREER

At one of the later Armory shows (not as exciting as the first one), Oliver won first prize, which was to have his own one-man show. He had come under the influence of Harold Waldrum, whose assistant he had become. Oliver was now doing minimal art. His show was a row of equal size canvasses, each with a different color triangle on it.

He also won a National Endowment for the Arts grant for five thousand dollars. Harold had written the proposal for him, something simple along the lines of, "I'm just a down-home Hispanic from Velarde, self-taught, who wants to have access to the great American art world." Oliver took the money and ran off to the East Village, following Harold, who had already gone there.

The last time I saw Oliver, he was wearing a grey sharkskin suit. His hair was short and he was thinner than ever. He gave me a sales pitch for a high-frequency whistle that could be attached to car bumpers to scare deer off the highway. I asked about his art and got a convoluted answer, something about doorways, abstracted, which was also what Harold was doing.

Oliver Ortiz returned to New Mexico to die of AIDS in 1984.

**Eugene Newmann, Harold Joe Waldrum,
Oliver Ortiz, and Reg Loving.**

HAROLD JOE WALDRUM

Waldrum was a fat, bearded, middle-aged artist who had started late and was unsuccessful. However, he was determined. He saw himself as an artist and pursued the role with a vengeance. A mythomaniac, he was always uttering pronouncements about himself. At some deep level Harold was a philistine Texan, but he kept it well hidden. His unshakable commitment to art came after having spent the first half of his life supporting a wife and kids as a teacher, conducting the high school band.

Waldrum's first style was garish, abstract expressionism. When I met him, he had done a stylistic about-face and was painting a series of crotch shots, abstracted and flattened, with the pattern of bedclothes featured between the legs in an amusing way. His next style was more regional: minimalist doors and windows, á la O'Keeffe. When he moved to the East Village, his work minimalized further to flatly colored squares, canvasses hung in series of three. From this seeming dead end Harold about-faced again, returning to New Mexico and doing semi-abstract old churches, more garish than minimal. These also related to O'Keeffe. Waldrum's last style hit the charts, although to me it was the most compromised.

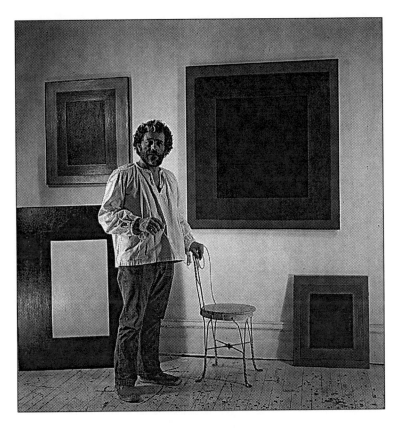

Harold Joe Waldrum.
Waldrum's "Windows" period came just before the churches.

When I first knew him he had gotten his hands on seven thousand dollars. He was involved in the demise of the artists' co-op at Shidoni, and helped sell their water rights to the utilities company. Harold put every penny into a color catalog of his work: the paintings of crotches, plus a few windows. He had this fancy brochure, but no money, no gallery, no nothing.

Icon Crossing Palace Avenue, **Harold Joe Waldrum, nd,**
Acrylic on canvas, 77 cm x 61 cm.
This is part of a series Harold called *Cunted Persons*.

We both moved to New York at about the same time, in the late
1970s. He found a place on East Second Street. The apartment was on
the top floor; when Harold went to inquire, it was full of applicants
being interviewed by the landlord. Harold asked if he could see the
roof, saying he was afraid of leaks. The landlord took him up and, as
they were alone, Harold said, "I have to have this place." He gave the
man two hundred dollars flat out, above and beyond the rent.

While I knew him in New York, he subsisted mostly on bread. Gerry Peters, the art dealer who later handled the church paintings, sent him a carton full of old clothes. Harold helped me find a place two blocks away on Third Street, also on the sixth floor. It was so awful I didn't even have to bribe the owner.

That East Village area was a bombed-out slum, crawling with derelicts. I saw no signs of gentrification in my neighborhood. That was a few blocks further up. The view from my window was of a sadistic Hell's Angel who tormented everyone who passed his doorway. What did me in was when my landlord stopped heating the building. The other tenants thought it a boon not to have to pay rent. They sat around their kitchen stoves. The building was ice-cold and smelled of gas. I lasted a few months and then begged my old high school friend Haseloff to let me share his loft in Soho.

Harold stuck it out for a couple of years, hovering close to his phone, waiting for a dealer to call. He even had a call-transfer service so he wouldn't miss his big break—this despite the fact that he hardly ever went out. His one contact with the art world was that he led an amateur choral group that met in the home of Bertolt Brecht's widow.

He didn't seem to have any social life. It was hard to type him sexually. He could have been one way or the other, or celibate. Waldrum had big, dark bags under his eyes. "I'm embarrassed by these rings under my eyes," he told me. "When I make love, if I'm on top they hang down."

Another example of his peculiar self-awareness was in Santa Fe when he posed for my sketch group. I was surprised he volunteered, as he was ugly. He brought along an umbrella for a prop. In one pose he pointed out that by leaning sideways he could come up with seven

folds of flesh along the side of his torso. Harold had psoriasis, which manifested in scaly irritated patches. He told me that the sun would reduce the irritation, but that if any part of his body remained covered, the rash would erupt there. He contrived to sunbathe nude. During the time he lived in Gusano, New Mexico, a little mountain village, he walked stark naked for miles out in the hills among the piñons, along an abandoned wagon route. In New York he sunbathed on the roof. Later in Taos he lived in the old Joseph Sharp studio. He walled off a small area by the door and would lie out there on a mat.

I went with my girlfriend Sarah to visit Harold in Taos. Harold was doing his new church paintings and already getting acclaim. The Anschutz College paid twenty thousand dollars for a huge one, an almost exact but simplified copy of a Polaroid he had taken.

Harold described to us how he painted it to the music of Bruckner, as if this made all the difference in the world. Though the painting looked simple, he was very proud of the many underlayers of color, some of which left an aura at the edges of shapes. He showed us a painting of a buttress, a mound-like shape at the back of a church wall.

"What is this shape?" he asked.

"A buttress?" I said.

Without answering, Harold unzipped his fly and took out his penis. He let it hang in front of the canvas so that it repeated the shape.

Although the church paintings were the beginning of Waldrum's success, the psychological turning point in his career had come earlier, just before he went to New York. It was his having killed a man. The trauma for him and the legend that grew in the local art world brought about the new intensity of his career. He grew into it and found the style to match his persona.

I knew him at the time of the incident and recollect the things he said then, before his many retellings had solidified into a kind of archetypical tale. The shooting took place in the little village of Gusano (which means "worm"). Waldrum had bought a stone building, an abandoned dance hall in the middle of this little enclave of rundown adobes hidden in the hills. He was enthralled by the primitive simplicity of the place. The neighbors helped him fix up his place and even found used appliances and furniture for him. They did the heavy work, putting in the insulation, which Harold couldn't do as he had hurt his back. He was elated to be accepted into the Spanish community. He pointed out to me where, through his back window, he saw Penitentes trudging across the hill to their re-created fourteen stations of the cross.

A mysterious girl named Candy seemed to be living with him, though she disappeared whenever he had visitors. A couple of times I caught fleeting glimpses of her, a wan blonde, a faded flower child.

The neighbors were insistently friendly, coming in and out all day. Harold fascinated them and was probably quite a diversion. According to Harold, several of the young men were petty criminals. Gusano was a hideaway where they had nothing to do but toy with a few stolen cars. Harold further said that he had been letting the locals dip into his marijuana supply. No wonder they were so helpful in fixing the place up.

Eventually Waldrum told them he didn't have any more marijuana. Resentment and threats ensued. A few nights later, Harold woke to hear a group of men force the door and come in. He saw their silhouettes. One had a gun in his hand. Waldrum was naked in bed.

He rolled behind the bed, where his gun was. He saw the man with the gun approaching. Harold shot. The man fell as the other men

gathered around the body and Harold bolted for the door.

Waldrum ran to his van, still naked, and drove off as they fired, bullets piercing the back of his vehicle. He drove to Gerry Peters' house in Santa Fe. There he called the state police, relating his story.

The next day, Gerry Peters drove Harold back out to Gusano. Two other friends joined them, and they all had weapons. Harold's house had been burned out and was still smoldering; only the stone walls were left.

Harold went to the state police. Rather than arrest him, they suggested that he disappear to avoid a vendetta. The dead man had a brother who had sworn vengeance. Peters, who apparently had a hidden arsenal, suggested that they go back and wipe out Gusano. Harold opted for a trip to Texas. He came back weeks later, hardly recognizable without his beard. He only stayed long enough to make arrangements, and then moved on to New York.

When I was living a block from him in the city, Harold was still having recurring nightmares. He would wake to the explosion of a gunshot. He tried to write a novel about the experience, hoping this would help him come to terms.

I stayed in New York for six months. Harold lasted a couple of years before he decided to move back to New Mexico and came to Taos, which was further from Gusano.

Packing to leave New York, Harold trudged up and down the five flights of stairs, loading his old yellow van with his art supplies. Each time he went up for another load he locked the van. When it was almost full, Harold came down and found the van door jimmied and all his art supplies gone.

I lost touch with Harold for a few years. Then I went to a lecture he gave at the Gerald Peters Gallery on the demise of the old mission

churches. Waldrum drove up in a Mercedes. He was clean shaven with very short hair, and he wore a dark suit. He was thin. Gone were the scraggly hair, grey beard, kibbutz hat and South American sweater. At first I didn't recognize him.

I watched a video he had helped to make about the advantages of the old-fashioned mud plaster compared with stucco, and I donated ten dollars. I heard he had also made a video about his art. I was told it showed him painting while an assistant with a spray gun blew vaporous mists onto the canvas to create some special acrylic effect, with background music by Bruckner.

RALPH LEON

R alph and I met when we were both exhibiting in an outdoor art fair. He was a wry little character, always wearing a yachting cap.

Leon had come to Santa Fe from Greece, where he did some kind of commercial art for the army. He had also painted, particularly a series of Greek men in cafes and playing Bocci.

Ralph met Irene Schio, a young Swiss woman, on a beach in Greece. They married, moved to Santa Fe, and had a son, Marco.

Painting at night, Ralph had a day job doing graphics for the Bureau of Land Management, a fact he didn't like to talk about. He liked to paint the old buildings of Las Vegas, New Mexico, and he also did a series on the amusement park in Atlantic City, where he had grown up.

Ralph Leon, 1977.

While Ralph painted in their garage, Irene set up a studio in their spare bedroom. She made collages and assemblages that had some of the spirit of Paul Klee. Her studio was a marvel of organization, thousands of found objects all laid out neatly on shelves and in drawers. She exhibited every year at the Keats Gallery and sold well.

Plaza Restaurant, **Ralph Leon, 1978, Oil, 30 in. x 23 in.**
This is Ralph's version of the Plaza Restaurant.
Later Peter Aschwanden did the menu cover.
This painting was in the *50 Years of Santa Fe Realists* catalog.

DAVID BARBERO AND PAUL SHAPIRO

David Barbero and Paul Shapiro were students at the Boston Museum School at the same time I was, in 1960 and 1961. However, I had come from and continued on to other art schools, while they had been there from the beginning and stayed on. I was asked to leave or paint in the prescribed style. One of the last paintings I did in Boston expressed my hatred of the school. It depicted five sycophantic students watching adoringly as our Maestro, Jan Cox, gave a demonstration. Barbero was one. I didn't know Shapiro, or I probably would have included him, too.

Almost twenty-six years later, walking down Canyon Road, I saw two disreputable looking, dirty, hairy hippie types coming towards me like a scene in a cowboy movie. "Aren't you Eli?" said the shorter of these desert rats. It turned out to be Dave Barbero. He and Paul Shapiro had just hit town from White Sands, where they had been camping and painting. On their way, they had stopped in Roswell and had checked out the Roswell Art Museum. They had come across a painting of mine, and found out I lived here.

Scrofulous looking as they were, who could have guessed (except maybe David and Kathleen) that they would soon be among the most successful artists in Santa Fe. For a few years they had just come out on summer painting trips. One summer I arranged for them to sublet a big house in Medanales, a Spanish-American village in the Chama River valley not far from where O'Keeffe had lived. There was a colony of weavers, including several interesting young women. David fell in love with one, Margaret, and thus began the complex transition of moving out West, which took a couple more years. He refers to that summer as "Madness in Medanales."

Paul Shapiro and David Barbero
at Ernesto Mayans Gallery, c. 1980.
Photo by Norman Zalkend.

Turn in the Road, David Barbero, 1984, Oil, 32 in. x 40 in.

Barbero and Shapiro painted in almost an identical manner. It was neo-Stieglitz Group, an appropriate style for O'Keeffe country. They depicted rollicking desert hills, multicolored rock formations, schematized greenery, and cotton ball clouds. Their paintings were an updated variation on Early American Modern, cartoony and ice cream-colored.

Santa Fe was tired of traditional Southwest regionalism and wanted something more contemporary. Barbero and Shapiro came on like gangbusters. They were in the right place at the right time. Soon other artists followed their lead, some of whom were their buddies from back East, others their students, and still others simply opportunists.

***Gathering Clouds*, Paul Shapiro, nd, Oil on linen, 20 in. x 24 in.
Photo by Dan Morris.**

In their first elation, David and Paul tried to name their movement. Shapiro came up with the acronym "ROPE," for "Radical Optical Perceptions Enthroned." We howled that one down. Barbero referred to the realist camp as "pagans," "limp-dicks" and "L.O.A.s" (Lovers of Adversity). The first meant unintelligently literal; the second meant uninspired. The third meant that we put too much effort into our work.

After one of Barbero's openings, at which he'd had many sales, the gallery gang adjourned to Ernesto's place on Martinez Lane around the corner from my house. We celebrated with a potluck feast

in Ernesto's back yard. It was a lovely summer evening. Dave proposed a toast: "To Eli, for introducing me to Ernesto and recommending my being in the gallery."

The tribute slid by, as Gene Newmann was regaling me with a marvelously lucid exposition of the rationale behind photorealism. Still, something felt wrong. Later, I realized that this had been a variation of giving a gold watch to the retiree.

My influence in Mayans' gallery began to wane. Not long before, I had talked him into gracing the gallery with his own name instead of "Primitives and Contemporaries." With the advent of Barbero and Company, Ernesto changed his letterhead from "important regional art" to simply "important art."

MORE ABOUT BARBERO AND SHAPIRO

Davidᵉ Barbero loved to talk about career management. He was a clever manipulator in an art world redolent with foolish amateurs. Barbero had four galleries handling his work in the Southwest. He managed a heavy exhibition schedule without mishap, and maintained control over the publicity. The same organizational capacity informs Barbero's style. He imposed a comprehensive system on nature, reduced it to simple components and recorded it in shorthand. We went out painting together and he did a large acrylic canvas in less time than it took me to only half finish a small watercolor.

After that, he cut back on painting outside, preferring to jot compositions in a tiny notebook, then work up the pictures in his studio. Once, when we were on my land by the Embudo River, David did five of these little studies, all of which he later worked up into major paintings. From two of the images he made popular posters. Barbero sells the little sketches, too, for quite a bit.

Paul Shapiro moved to Santa Fe a couple of years after Barbero. He brought his new wife, the fifth, I believe; this was Penelope Place,

from the Rockefeller family, young, big and statuesque, a video artist.

With or without Penelope, Paul could always be found at openings and parties. He was simple, almost childish, and it always surprised me that he had an unerring perception of who's who in the art scene. This and his career were the alpha and omega of his conversation. Paul possessed a charisma, an animal vitality. Though Barbero beat him into Ernesto's gallery, he found other venues and moved up through the galleries. He and Barbero kept pace with sellout shows and rising prices.

Barbero and Shapiro should be credited with heading a movement. Their candy-coated landscape vision became ubiquitous. Santa Fe was inundated with lithos, monoprints, posters, brochures and cards by them and their followers. They changed the look of art in Santa Fe, their cosmopolitan style having replaced the frontier western look of Southwest regional art.

AFTERWORD

The sophistication of the new artists featured in this book contributed to the gentrification of Santa Fe. What Santa Fe was losing in uniqueness was perhaps compensated by the increasing range of cultural stimulation. The Regional Realism to which I'd been dedicated had come to seem simplistic, like pretending we could maintain our small-town feeling. This book has been a memoir of a few youthful years when we believed we were living in "the city different," capital of "the Land of Enchantment."

POSTSCRIPTS, 2006

The Santa Fe Studio School, 1983.
Left to Right, Top: Ernesto Mayans, Janet Russek, David Sheinbaum, Melinda
Miles, Sarah McCarty.
Middle: Bernard Plossu, Carol Mothner, Joel Greene.
Bottom: Cathy Folk-Williams, Eli Levin, Daniel Zolinski.
We each taught out of our own studios.

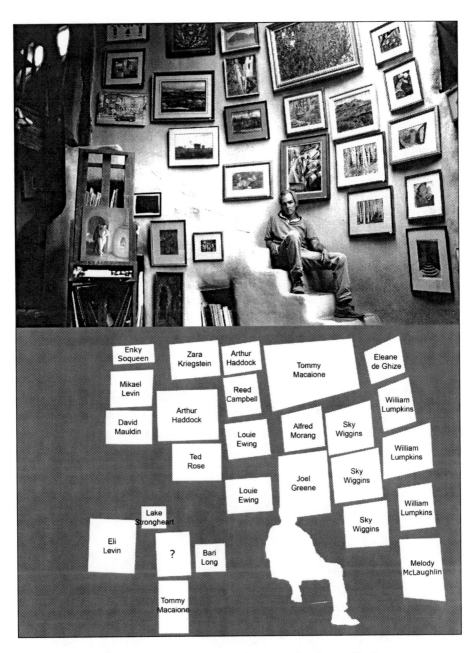

**I used this photo for an invitation to a sale of my collection.
The painting on my easel was bought by Linda Durham.
Photo by Sami Keats. Graphics by Cheryl Anne Lorance.**

Deanne Romero

Deanne lives in Amarillo, Texas, where she practices as a therapist, paints and writes poetry.

She has come to Santa Fe several times, often to give poetry readings with her young friend John Romero. Their poems, extremely emotional and romantic, are guaranteed to enliven an evening spent in a coffee house.

Deanne's paintings, simple painterly abstractions, have some of the emotional immediacy of her poetry.

**Deanne Conner
at Ojo Caliente, c. 1988.**

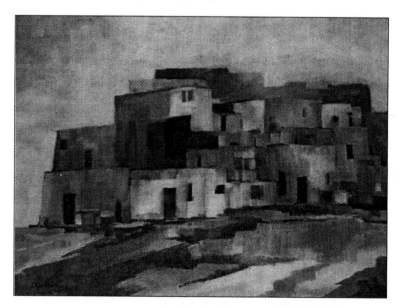

A Taos Memory, **Deanne Conner, c. 1971, Oil on canvas, 20 in. x 24 in.**

Walter Chappell

The last time I saw Chappell, he was living in an isolated adobe on the far side of the Rio Grande, near Velarde. We were outside by the river. Walter was naked except for a thong belt from which hung a loop that was supporting his penis. He had rigged a cage-like trap made of saplings in the river. We approached it and discovered that he had caught a trout.

Tom Hamill

Occasionally I see Tom walking downtown, still tall and imposing but looking a bit dazed. He doesn't usually recognize me. I've heard that he's lived in assisted housing for quite a few years. It's been even longer since I've heard anything about his art.

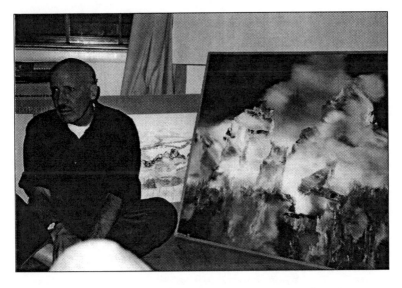

A current photograph of Tom Hamill with a painting from c. 1980.

David McIntosh

Recently I sold my house in Santa Fe and I now live at the end of a dirt road near Dixon. Coincidentally, David lives just up the road. We are on the same irrigation ditch, and we both attend the acequia meeting every spring to discuss water issues. David, as handsome and elegant as ever, still paints restrained, poised abstractions.

Though I had not had news of him in all the intervening years, I recently found his name in print twice, and in both instances concerning famous people. When Agnes Martin died in 2005, McIntosh, a good friend of hers, published an appreciation. And while leafing through the collected poems of James Merrill, I found one dedicated to David McIntosh. It described an enchanting house party in a secluded New Mexico retreat.

Peter Aschwanden

Two years ago I ran into Aschwanden at an opening at the Eldridge McCarthy Gallery, where I was exhibiting. Peter still had the 1960s look, with long scraggly grey hair, a battered and stained

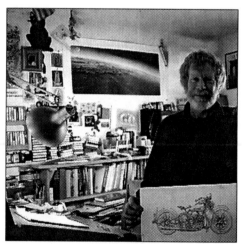

Peter Aschwanden, 2000.

cowboy hat and a missing tooth. His lady-friend, who was working for the gallery, showed me photos of his paintings. Strong and imaginative, they depicted scenes from the chaotic life of a swollen-headed character.

Grapefruit Head II: Plans and Designs, Peter Aschwanden, c. 1990's,
Mixed media on canvas, 30 in. x 36 in. 3-D corner-piece painting.

Aschwanden rarely exhibits. He recently designed a wonderful poster for the Plaza Café that depicts it as it might have looked in the 1940s. Sadly, he recently passed away.

Plaza Café Menu,
Peter Aschwanden.

Ford Ruthling

While Ford's paintings have not been much in evidence in the galleries, the few I've seen have been decorative, incorporating folk art motifs.

In 2005 he received the Governor's Award for Excellence in the Arts. In the newspaper photo he looked like an aging matinee idol.

Ted Rose

My neighbors on Camino Don Miguel, Ted and Polly Rose, commissioned me in the mid 1980s to paint a portrait of their fifteen-year-old daughter Molly, a lovely girl who was studying ballet. She later danced with the Santa Fe Opera. The Roses bought several other pictures from me including a swarming dance hall scene that I called "Can of Worms."

When Polly worked in the administration office at St. John's College she arranged for me to have an exhibition in the college gallery. I showed still-lives of skulls, both animal and human. Polly also typed my manuscripts, including the first draft of this book.

Ted became a nationally known watercolor artist, widely considered to be unequaled in his depiction of railroad subjects. I wanted to trade with him, but his pictures sold as fast as he painted them. Ted Rose died in 2002, age 61, from cancer.

**Bad Moon Rising
(after A. P. Ryder),
Ted Rose, 1995,
Watercolor,
11 in. x 15 in.**

Steve Catron

One often sees Steve walking around Santa Fe, lost in thought. On occasion he will reminisce about the old days, and he has amazing recall. Catron has not exhibited in years. He claims to have stopped painting and even to have destroyed his work. I wish this wasn't so, as I thought he was the best artist of our generation. Catron continues to live in the house where he grew up. He cared for his mother until she passed away.

Carol Mothner

Carol's work has always sold well. She has had several sell-out exhibitions at the Gerald Peters Gallery. Her paintings have become obsessively smaller and tighter. For a few years she has been painting variations of an antique Madonna figurine. Since 9/11 she has incorporated the names of the dead in miniscule script. The gallery supplies a magnifying glass to viewers.

Don Fabricant

The last time I met with Don we traded some art and some furniture. A small round table and a rocking chair are here in this very room as I write these words.

Fabricant had just been remodeling his studio, and was anxious to get back to painting. His art was abstract at the time, mostly patterns of loosely painted triangles, but he showed me a searching self-portrait that was quite realistic. I felt that Don, so complicated and often distracted, might be on the verge of doing some strong, intensely emotional paintings.

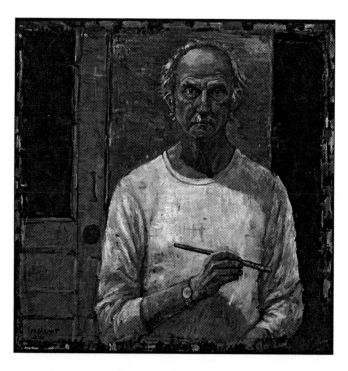

Self-Portrait, Don Fabricant, 1990, Oil on canvas, 36 in. x 36 in.
From my collection, this was one of Don's last paintings.
Photo by Cheryl Anne Lorance.

That was in 1993. Fabricant died before he got to use his studio, his death as romantically tragic as his life.

Valerie Frank, an ex-girlfriend who was still close to Don was living in his guest house. She told me that Don was depressed about turning sixty and was struggling with drug use. The night he died he had been out dancing as was so often his wont at Club West (we called it Club Waste). He had brought home a young woman who, however, didn't stay.

The next morning Valerie checked in to see how Don was doing and found him in his closet, dead from self-strangulation.

I stayed in touch with Valerie, who did some wonderful prints in my etching group. A couple of years after Don's death I visited Valerie and her boyfriend Jim Mafchir. They showed me two enormous white plastic tubes, each about six feet high and thirty inches in diameter. Packed into those tubes was all the art Fabricant had left.

Don Fabricant standing of front of *Menagerie*, 1990. Photo by Edward Vidinghoff, published in *The New Mexican*.

Pamela Levi

While Pam was with Don Fabricant I hadn't thought of her as a serious artist though she had a degree in fine art from the University of Northern Iowa, where she'd studied for five years. She only occasionally sketched or did a watercolor.

In Israel her husband Itamar Levi was a therapist and active art critic. Pam began painting large, strong works. When the famous artist Jim Dine was in Jerusalem he saw Pam's paintings and told her to apply for a Guggenheim grant. She did, successfully.

Pamela Levi.
Photo by Lisa Pleskow.

Pam took a studio that was in a subsidized Jerusalem warehouse full of artists. She began a series of paintings depicting dislocated people in detritus filled landscapes. These figures were often naked or partially clothed in ambiguous scenarios fraught with tension.

***Luna Park, Two Girls*, Pamela Levi, 1987, Oil on canvas, 55 in. x 79 in.**

Pamela Levi became one of Israel's most famous young artists with many exhibitions including retrospectives in both the Jerusalem and Tel Aviv Museums.

Pam and Itamar eventually divorced. Some of the things she said about him seemed a bit paranoid. As the years passed she drank increasingly. Pam took cures several times and was sober the last few times I saw her, but her health had deteriorated. She continued to paint intense, disturbing paintings right up to her death in 2004.

Sam Scott

Sam Scott at my opening at Cline Fine Arts in the 1990'

Sam has been the most successful of his generation of Santa Fe abstractionists. He had a big retrospective in the New Mexico Museum of Fine Arts in 1992, a rare honor for a local artist. A hardcover book on his art came out in 1993.

Sam gave a talk in the Museum's Saint Francis Auditorium. The subject was spirituality in art. He drew a large audience, and the crowd responded enthusiastically. I was about to slink away before the question and answer period when a man stood up in the third row, visibly crying.

"Thank you, Sam, that meant so much to me, I just can't thank you enough. Your example has changed my life."

I read somewhere that Sam Scott even addressed the United Nations. When we run into each other Sam gives me a big bear-hug.

Sam Scott in his studio, 2006. Photo by Cheryl Anne Lorance.

Mullen, Sam Scott, 2006,
Oil on canvas, 80 in. x 54 in.

Frank Ettenberg

Frank still paints elegant abstractions. For a few years we've been exhibiting in the same gallery, and his paintings sell even less often than mine.

Since Frank married a woman from Germany, his work has been better received over there than here. The Germans have a lively art market, and have a special sensitivity to Jewish art.

Recently Frank separated from his wife. He had a big studio sale before moving. His workspace was large and well designed. My impression at the sale was that cumulatively, his work was perhaps a little bland. Not that there weren't many fine paintings.

Frank Ettenberg in 1997 at his opening, the Austria Tabakmuseum, Vienna. Photo by Edgar Klein.

Near Calvary, Frank Ettenberg, 1997, Acrylic on canvas, 31.5 in. x 39.5 in. Collection of Franz Ringel, Vienna, Austria.

Gene Newmann

Gene built a house and studio in Ribera, New Mexico, and has not been very visible, though he sometimes comes to art openings, including mine. I still love to listen to his commanding low gravelly voice and admire his perceptive ideas about art.

He exhibits at the Linda Durham Gallery and is well thought of. Not as decorative or saleable as most of Linda's artists, Newmann's art has become increasingly cryptic, the content seeming to be buried or obliterated under the paint.

Incidents of Travel, **Eugene Newmann, 1988,
Oil and mixed media on canvas, 48 in. x 76 in**

Forrest Moses

Forrest has had a successful career, continuing to paint semi-abstract, lush landscapes. His 2005 exhibit at LewAllen gallery was selling works priced between twenty-five and forty thousand dollars.

Fritz Scholder

Fritz, who died in 2005, was probably the most famous contemporary artist to come out of Santa Fe. Throughout his life he continued to exhibit in various local high-end galleries, eventually returning to Indian subject matter. Yet he had long since moved out of New Mexico, living in Scottsdale and New York.

Despite publications about him, including an oversize coffee table book by Rizzoli, he never achieved the big time outside of the Southwest. Many artists feel that Fritz's early paintings were his best.

Whitman Johnson

Whitman continues to paint, his wife Linda Monacelli to write poetry. Whitman's landscapes have become so closely observed that he will often work a painting of a particular location and season over several years.

Because of his rigorous standards, Whitman has not had gallery representation in years. His paintings deserve to be better known.

Sangre de Christos, Whitman Johnson, 1985, Oil, 19 in. x 24 in.

Tim Z. Jones

Tim has led a checkered existence. He stopped painting to study nursing and lived in Alaska for several years. Not long ago he telephoned me from Oregon, asked if I would fill out a questionnaire from the Catholic Church. Its purpose was to enable him to marry a young lady from Indonesia. He was living in a truck that he had fixed

up as a mobile studio and he also had a boat that he hoped to renovate. He invited me to come and paint with him.

Timothy Z. Jones and new wife Anik, Seattle, 2005.

David Pearson

David is a successful sculptor, exhibiting on Canyon Road at the Patricia Carlyle Gallery. Patricia is his wife. They have a nice little ranch out towards Galisteo, with horses and a sculpture studio. A book on his work is in process.

Dave's sculptures are almost all variations on a theme, a standing sylph-like woman swathed in long drapes.

Kathleen Pearson Richards

Kathleen moved to Kansas with their three children. She has intermittently managed to complete her art education, receiving an M.F.A. in 2005.

Her paintings are powerful evocations of loss and pain.

Jo's Alhambra, **Kathleen Pearson Richards, 2004,**
Intaglio and watercolor, 9 in. x 7 in.
Kathleen did an etching of a doorway at the Alhambra,
then hand painted more than twenty variations.
She exhibited them in my studio in 2005.

Joel Greene

Joel continues to thrive as a latter day Cubist, still exhibiting at
Ernesto Mayans Gallery.

Joel built an ideal studio east of town on Nine Mile Road, where
he runs a well appointed etching workshop. Though he spends long
hours in his studio, he has been living with his mother, taking care of
her in her old age.

In 2004, New Mexico Magazine published a hardcover book on
his paintings.

Rock Formations Near Cundiyó, **Joel Greene**, 2002, **Oil on canvas, 12 in. x 16 in.**

Harold Joe Waldrum

Harold came into his own when he returned from New York to Taos. Moving into Joseph Sharp's old studio, he began painting abstracted churches, which he showed at Gerald Peters Gallery.

After considerable success, he had a falling out with Peters.

Harold bought a nine thousand square foot space in downtown Truth or Consequences, a lumber supply building that he slowly converted into an upscale gallery and studio, Rio Bravo Fine Arts.

Waldrum evolved into something of a megalomaniac, enormously heavy, a town character of great panache. He wrote an unpublished novel about his traumatic experiences in Gusano. It starts out factually, but after the shooting it evolves into a utopian adventure story. Harold becomes the master of an enclosed compound, a kind of *Heart of Darkness* in reverse. Another book, which Harold published about himself and his work, is titled *Ando en Cueros*, or, in English, *I Walk Stark Naked*.

Harold died in 2003 of colon cancer.

Harold Joe Waldrum, 1934-2003

La cruz arriba de la iglesia perdida de Cleveland, New Mexico,
Harold Joe Waldrum, 2002,
Acrylic on canvas, 53 in. x 53 in.

Ralph Leon

Shortly after Ralph finally retired, Irene left him for a rock climber. Marco went to college.

Ralph would come to my drawing group, where we all loved him and, behind his back, referred to him as "little Ralphie." He was restless, alternatively feisty or forlorn, and would come late or leave before the class was over.

Ralph was doing some strong paintings of Fiesta scenes in the Plaza. He suddenly died from a heart attack while taking a shower.

Owl's Liquors, **Ralph Leon, nd, Oil on linen, 15 in. x 25 in.
Still exists on the corner of St. Francis and Paseo de Peralta.**

David Barbero

David died unexpectedly in 1999, age 60. It was while on an airplane, going to Greece to teach a Tai Chi workshop. This was a blow to his many friends, especially to his companion Margaret, who had been with David since the days of "Madness in Medanales."

Barbero had achieved fame and fortune with his landscape paintings, selling steadily in Mayans' gallery as well as outlets in Colorado, Arizona and Texas. He had an architect design a fancy studio that overshadowed his house on Nine Mile Road, near Joel Greene's. The studio balcony looked like a suspended oversize grand piano.

In the 1990s the art market slumped and Barbero's career began to falter. Furthermore, he painted an almost abstract series based on doorways, not so appealing to tourists as his landscapes.

Despite some retrenching and repetition, Barbero painted some of his strongest landscapes in his last year.

Margaret helped compile a major book on David's work, but at the time of this publications, it is still in the manuscript stage.

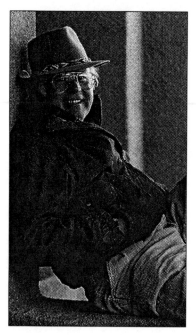

David Barbero.
Photo by Joy Waldron.

I was philosophical in the words I said at your two memorials, in
 the East and here in the West:

Thank you David
For great romance,
for always challenging me to think bigger and travel farther than
 I ever expected.
Thank you for teaching me about the colors of light and shadows
and for painting your imagination into beautiful reality on your
 canvases.
That you for your guidance in Tai Chi,
and for sharing your love of music, from Coltraine to Wagner.
I especially loved all the happy times in the kitchen
creating wonderful palettes of flavors for us, for our friends and
 families.
As for our time together on this earth,
I'm remembering what you said to me from the time we first met:
Hold on tightly, let go lightly.
I'll see you in the infinite array of colors each day.

Elegy for David Barbero, June 1999. Written by Margaret Wood.

Paul Shapiro

Paul is going strong. Sardonic and amusingly outspoken, he mocks Barbero for having repeated rather than re-invented himself.

Shapiro has gone through many styles. After his Barbero-like landscapes there were depictions of shaman emanations, a series of frantic painterly abstractions, big collages that combined central calligraphic strokes with geometric patterns and, most recently, an almost monochrome surface covered with agitated ripples. A few years ago Shapiro headed an R&B group that played various local clubs.

Shapiro has tried several times to leave Santa Fe and move on to various other art centers—Long Island, the West Coast, Europe—but he keeps coming back.

Louie Ewing and Arthur Haddock

These two exemplary artists died before 1980, but I would like to say a few words about their posthumous reputations.

We've all heard the old saw that artists are discovered after they die. The opposite is more common.

Though Ewing's silkscreen prints were perennial favorites, since his death they have almost disappeared from the market. There has not been a book about his work nor has there been a retrospective.

Ernesto Mayans published an extensive hardcover book on Haddock's life and work. However, the estate was mismanaged. Except for a few lackluster paintings at the Mayans gallery, Haddock's work hardly ever appears on the market or in public collections. Let that be a warning to us all.

A FINAL COMMENT 2006

L ouie Ewing and Arthur Haddock, who belonged to the original Santa Fe art colony, were mentors to me late in their lives.

My generation revived and greatly expanded the art scene. In our mature years this scene has grown more complex, moving beyond the scope of my youthful memoir. I've indicated a few individual threads of development in my postscripts.

Recently the Santa Fe art community has been undergoing major transitions. The art market has become the second largest in the United States. And there has been an influx of art patrons, bringing national and even international taste. Perhaps a dedicated art lover might still find local works of complexity and depth, but there is no longer a core community.

I leave it there. A new generation will surely redefine the Santa Fe art colony.

Printed in the United States
70103LV00007B/14